LEBRUN

LE BRUN

LE BRUN

CHARLES LE BRUN

FIRST PAINTER
TO
KING LOUIS XIV

BY
MICHEL GAREAU

with the collaboration of
LYDIA BEAUVAIS
Chargée de mission (LE BRUN project), cabinet des dessins at the Louvre

HARRY N. ABRAMS, INC., *Publishers*, NEW YORK

Text and notes on the paintings by Michel Gareau
Notes on the drawings by Lydia Beauvais

We would like to thank the following people for their collaboration:

Roseline Bacou, Cabinet des dessins du Louvre

Béatrice de Boisseson, Réunion des Musées Nationaux

Lucia Cenerini, Italian Embassy

Philippe Couton, Réunion des Musées Nationaux

Révérend Père Guy Couturier, Theologian

Liliane Desvergne, Château Vaux-Le-Vicomte

Valérie Durey, Musée des Beaux-Arts de Lyon

Jean Guimond, Linguistic Reviser

Catherine Giras, Musée des Beaux-Arts de Dijon

Vivianne Huchard, Musée des Beaux-Arts d'Angers

Pierre Lorrain, National Art Foundation of Canada

Annie Madec, Réunion des Musées Nationaux

Didier Marty, Musées et Monuments de France

Hélène Meyer, Musée des Beaux-Arts de Troyes

Annick Notter, Musée des Beaux-Arts d'Aras

Inna Orn, Pushkin State Museum of Fine Arts

Yves Pépin, External Affairs Ministry

Roger Peyrefitte, Author and Historian

Françoise Portelance, École Nationale Supérieure des Beaux-Arts

Natalia M. Revay, Russian Interpreter

Pierre Rosenberg, Musée du Louvre

Gianfranco Sylvestro, Instituto Italiano Di Cultura

Elisabeth Tatman, Dulwich Picture Gallery

Jacques Thuillier, Collège de France

Michaïl Yu Treister, Pushkin State Museum of Fine Arts

Comte Patrice de Vogüé, Château Vaux-Le-Vicomte

**The publication of this book was made possible by the support
of the National Art Foundation.**

Co-ordination
Philippe Jacques

Design
John R. Payne

Translation
Katrin Sermat

Original title
Charles LE BRUN: Premier peintre du Roi Louis XIV

Copyright © 1992 N.A.F.C.

ISBN 0-8109-3567-8

Published in 1992 by
Harry N. Abrams, Incorporated, New York
A Times Mirror Company

Printed and bound in Japan

CONTENTS

BIOGRAPHY

CONCLUSION

LE BRUN'S TECHNIQUE

NOTES ON THE DRAWINGS

NOTES ON THE PAINTINGS

BIBLIOGRAPHY

REFERENCES

PHOTOGRAPH CREDITS

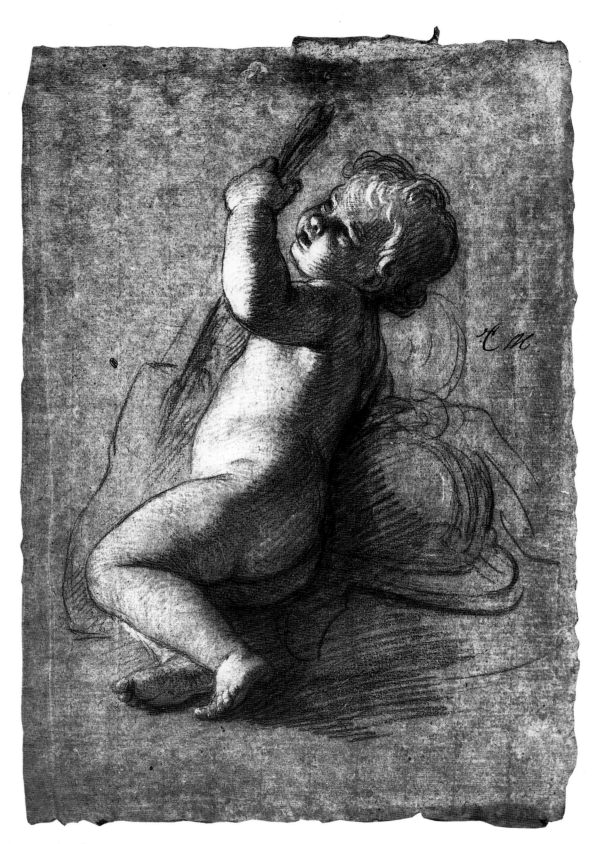

Drawing by LE BRUN

I-1

THE EARLY YEARS

The son of master sculptor NICOLAS LE BRUN and Madame JULIENNE LEBÉ, CHARLES LE BRUN was born in PARIS on February 24, 1619. One of eight children (he had three brothers and four sisters), he was a child prodigy in the fullest sense of the word. [1] As always, a little legend has been mixed into the story: it was said that the three-year-old child stole bits of charcoal from the grate and used them to draw on the mantelpiece and hearth by firelight.[2] A more official account, however, states that at a very early age, he sketched huge heads on the floor tiles of the family home. [3]

At the age of nine, LE BRUN already knew how to handle clay and carve wood. The masks, eagles and griffins that he produced during this period aroused amazement; these small works were still in existence at the end of the eighteenth century. It was said at the time that these first attempts demonstrated that LE BRUN could have gone on to become a talented sculptor had his inclination not led him toward painting. A sculpted wooden figurine of BACCHUS made by the young artist was remarkable enough that casts of it were preserved. It is evident in the great many drawings that LE BRUN later made for statues that he had been familiar with the laws of sculpture for a very long time.

At the age of thirteen, LE BRUN worked with FRANÇOIS PERRIER, who had lived in ROME for many years and had brought back from Italy numerous drawings of ancient statues and bas-reliefs. In the drawings that PERRIER gave him, the boy had his first glimpse of antiquity. Shortly afterward, PERRIER returned to ITALY.

At the age of fifteen, LE BRUN made the acquaintance of SÉGUIER, who was then Chancellor to LOUIS XIII, and later to LOUIS XIV. The writings of the master sculptor DE PILES, who was working at the time with NICOLAS LE BRUN, give his version of the meeting between the young CHARLES and CHANCELLOR SÉGUIER:

> "The sculptor (Charles' father, Nicolas) was working on some projects in the gardens of the Hôtel Séguier. He was accustomed to bringing his son along and having him copy a few drawings under his supervision. One day the Chancellor was taking a walk, and saw the young man drawing with such ease and enthusiasm for his age that he was convinced that this was no ordinary talent. Séguier found the child's countenance appealing and as he was touched by his sunny disposition, he asked him to bring him drawings from time to time; he subsequently expressed a desire to oversee his development and gave him money to encourage him.
>
> These rewards motivated the youth to make such surprising progress that the Chancellor recommended him to Simon Vouet, who was in the process of painting the library of the Hôtel Séguier and who was considered by his fellow painters to be the Raphael of France."[4]

According to the biographer JOUIN (1889), there is undoubtedly some truth to this account, but the author did neglect to identify the person who actually introduced the young LE BRUN to CHANCELLOR SÉGUIER. It was M. DE BAUVALLON, who was at the time lawyer to the Council. Jouin confirms this fact with a letter written by LE BRUN on October 17, 1644.

The circumstances of the encounter between SIMON VOUET and LE BRUN had relatively little influence on LE BRUN's later development. The master and his pupil soon quarrelled; SIMON VOUET was of a nervous disposition and did not take kindly to praise of his students. From then on, LE BRUN had no patience with any artistic authority. He complained to SÉGUIER that he was only given second-rate apprentice tasks. VOUET promised the Chancellor that he would entrust his pupil with the decoration of part of the gallery, but neglected to keep his promise.

Because of this attitude, LE BRUN had lost interest to the point that he left VOUET in order to spend time at the King's palace at FONTAINEBLEAU where the beautiful paintings decorating the royal residence attracted the curious from far and wide. He made many studies there and was not yet fifteen when he produced a miniature copy of RAPHAEL's *Holy Family* with such precision and accuracy, and rendered the expressions with such perfection that the only obvious difference between the two paintings was their size.

Even if LE BRUN did not work for a long time under VOUET, he nevertheless learned an important lesson from him. VOUET was skilled at large-scale decoration and at devising complicated symbols. He also introduced LE BRUN to the majestic and excessive art of Italian architecture that was to influence French artists until the end of the seventeenth century.

> *"But LeBrun's artistic output greatly surpassed that of Vouet: the latter had only trained painters, whereas LeBrun went on to train whoever was required for the production of royal furnishings: sculptors, tapestry-makers, engravers, cabinetmakers, embroiderers."*
>
> *"In short, Vouet can scarcely be compared to LeBrun when one considers that the latter left his mark on a particularly varied body of work, and almost innumerable elaborate long-term projects. Though both were of the same school, LeBrun distinguished himself by expanding his artistic scope and frontiers."*[5]

After completing his studies of works at the palace of FONTAINEBLEAU, LE BRUN returned to CHANCELLOR SÉGUIER's employ. The first project that he undertook was an allegorical painting of CARDINAL RICHELIEU, who was one of LOUIS XIII's ministers. He was soon rewarded for his efforts. RICHELIEU appreciated the painter's skill and commissioned three paintings:

- *The Abduction of Proserpine*
- *Hercules Feeding Diomedes to the Mares*
- *The Death of Hercules on the Pyre*

NIVELON tells of how NICOLAS POUSSIN, when invited to give his opinion of these paintings, replied *"If they were done by a young man, he will one day take his place among the great painters."*[6] The three works were displayed at the royal palace.

On June 26, 1638, the nineteen-year old LE BRUN was given, by public declaration, the title of *Painter to His Majesty King Louis XIII.* Though he was still a very young man, LE BRUN was already receiving important commissions. Since he made a veritable name for himself with these paintings, it is therefore no wonder that his thesis drawings were eagerly sought after.

It was the custom of the time for students in the faculties of Theology, Law, Medicine and the Arts at the UNIVERSITY OF PARIS to publish their theses. Candidates usually dedicated their works to important figures and the frontispiece of the volume included a drawing that made clever allusions to the merits or functions of the person to whom the thesis had been dedicated. The wealthiest students seized the opportunity to engage LE BRUN, thereby adding a little grandiose flattery to their theses to render them more eloquent. Four of these thesis drawings are known to us today:

- an allegory representing Providence descending from Heaven with a newborn infant for LOUIS XIII (this child would become LOUIS XIV)
- an allegory on the power and integrity of CARDINAL RICHELIEU, minister of LOUIS XIII
- MINERVA holding a medallion bearing the portrait of CHANCELLOR SÉGUIER
- a tribute to CLAUDE BOUTHILLIER, Superintendent of Finance

During this same period, LE BRUN strove to become more cultured and to make his way into literary circles. To this end, he executed drawings which were to be engraved in the frontispieces of the great literary works of the time. Among these were CORNEILLE's play *Horace*; *L'Amant libéral*, by SCUDERY; *L'Aveugle de Smyrne* by BOISROBERT; and the pastoral tragicomedy *Il Pastor Fido* by GUARINI.

Aware of his growing talent and popularity, the young man wished to round out his artistic development. For this reason he felt a increasing need to perfect his knowledge of art in ROME. In the tradition of all great painters throughout history, he wanted to make the journey to ITALY, and the time had come for him to realize this final step in his education.

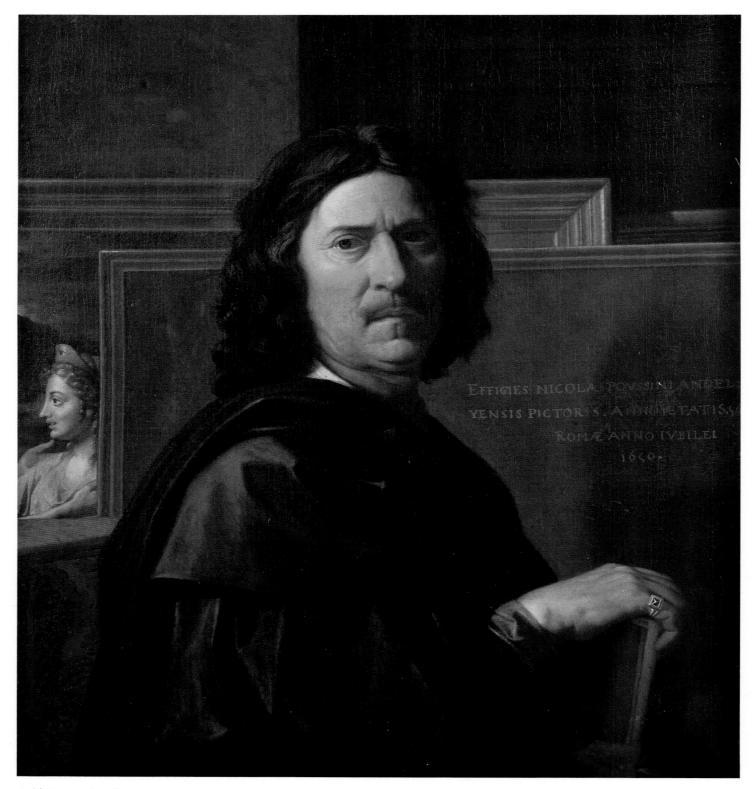

Self Portrait of POUSSIN

CHAPTER TWO

THE JOURNEY TO ROME

Determined as he was to see ITALY, LE BRUN did not overlook anything that could make his stay beyond the Alps more fully profitable. He knew that ROME was the one place on earth where everyone went to immerse themselves in antiquity and that the precious artifacts there would soon enlighten him about the great names of ancient ROME, men such as HOMER, HESIOD and VIRGIL.

Being by nature very active, and anxious to attain the pinnacle of his art, LE BRUN paid meticulous attention to his education just before leaving for ITALY. *"He following a self-prescribed programme of careful reading in sacred, secular and poetic history."*(7) He also eagerly sought out scholars who could expand his knowledge of the subject. He attentively studied drawings of medals and anthologies of writings on ancient artistic movements.(8) But what he appreciated most of all during this period of initiation was the advice of POUSSIN, recently returned to FRANCE from ROME at the request of LOUIS XIII. LE BRUN did his utmost to attract POUSSIN's attention and quickly succeeded. As previously noted, he had been very flattered by POUSSIN's opinion of the three paintings at the royal palace.

In 1640, LE BRUN was only 21 years old and POUSSIN was 46. The young man wanted to leave for ROME, the older one had just returned from there. The mutual esteem they felt served to draw them closer together. LE BRUN had tremendous respect for POUSSIN and hoped to take advantage of his extensive experience of nearly 20 years in ITALY.

POUSSIN was named *First Painter to his Majesty Louis XIII, King of France.* He assumed general direction of all paintings and ornaments undertaken by the Crown for the

adornment of the royal residences. Before any painter could execute a work for his Majesty, his drawings or sketches were first examined, corrected and approved by POUSSIN. With POUSSIN's nomination, VOUET, who had been general director of projects at the LOUVRE found himself dispossessed and demoted by the King to the rank of a minor painter.

The next two years proved catastrophic for POUSSIN's morale. The favours he enjoyed as First Painter had aroused the jealousy of a number of artists, among them VOUET and his supporters. POUSSIN's reputation was besmirched by unfavourable criticism and everything he did and said was systematically denigrated; attempts were made to embroil him in all kinds of political problems. Finally, POUSSIN, disabused and at the end of his patience, left PARIS towards the end of September 1642. On his way he stopped at LYON in the south of FRANCE, where LE BRUN joined him several weeks later. POUSSIN and his young travelling companion arrived in ROME on November 5, 1642.

The young man of 23 had prepared himself well for his study trip. CHANCELLOR SÉGUIER had promised him a pension of 200 crowns per year for the duration of his stay in ITALY. He also had with him a letter from the Chancellor recommending him to Cardinal ANTONIO BARBERINI, camerlingo and superintendent of finances. In addition, his Majesty the King, LOUIS XIII, had sent a personally signed dispatch to POPE URBAN VIII requesting his kindness towards the Crown's young protegé.

The young apprentice painter even managed to obtain the Pope's permission to erect scaffolding wherever he wished in order to study certain works more closely. He worked ceaselessly to perfect his art; ancient monuments were the object of his constant attention.

"*There was not a single beautiful ancient statue, nor a bas-relief in Rome that the young student did not sketch.*"[9] He carefully studied the different customs of the ancients, how they dressed, how they exercised both war and peace, their pageants, their battles, their triumphs, as well as their buildings and the principles of their architecture. [10] He examined ancient art with an archaeologist's eye, taking particular interest in the details of costumes, helmets, armour and weapons. He made miniature copies of RAPHAEL's paintings, he studied CARRACCI, he drew furiously; in short, he returned to FRANCE with nearly 500 drawings and paintings in his notebooks.

LE BRUN remained faithful to POUSSIN during his three-year stay in ITALY. He accompanied the great master on walks, listened respectfully to his artistic theories, and, above all, he studied his style and sought to assimilate his technique, searching for the key that would enable him to realize his ambition of equalling or even surpassing the only artist he recognized as his superior.

The young artist benefitted so greatly from his lessons and assimilated POUSSIN's technique so well that *"he produced a painting in secret and arranged for it to be publicly exhibited on a holiday, without anyone knowing whose work it was. The Roman clergy felt that the work was charged with originality and looked for the mark of a French painter. Public opinion designated Poussin as the creator of the canvas, entitled "Horatius Cocles." The master soon learned what was going on, after receiving various compliments for having produced the painting."* LE BRUN made a point of joining the crowd that flocked around POUSSIN one morning as he was on his way to see the painting in question. According to NIVELON, POUSSIN himself praised the beauty of the painting after having seen it and could not hide his concern that its creator could prove to be a dangerous rival. *"For a long time afterward Horatius Cocles was considered to be Poussin's work, even in Paris."*[11] Today we know of several paintings that LE BRUN executed in POUSSIN's style. The most important of these are:

- *Horatius Cocles*
- *Mucius Scaevola*
- *The Death of Cato*
- *Allegory of the Tiber*
- *The Slumber of the Christ Child*

We must be careful today not to compare POUSSIN and LE BRUN to determine which of the two was the better. Even if a fundamental part of their approach was similar, the two men were different. LE BRUN was steeped in the pomp and pageantry of the royal palace, and in the King's wars and bloody conquests. POUSSIN, on the other hand, lived most of his life in seclusion and quiet contemplation, in his little house in ITALY where he went so far as to adopt the local dress and language. *"Poussin is therefore known as the painter-philosopher while LeBrun is the decorative painter and historian of the Grand Siècle."* It can be said that both painters achieved their dream of being held in high esteem, each in his respective country.

At the end of his three years in ROME, LE BRUN had acquired a considerable body of knowledge; he had learned all that he could in ITALY and, armed with numerous documents, he resolved to return to FRANCE. Although the Spanish ambassador and cardinals had invited him to visit their country, it was his love for his homeland that won out. [12]

Which one is by LE BRUN?

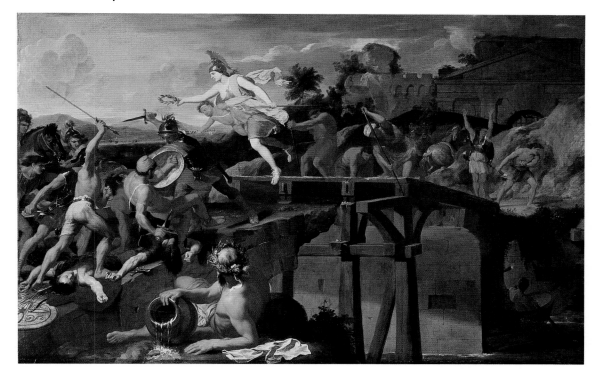

II-2

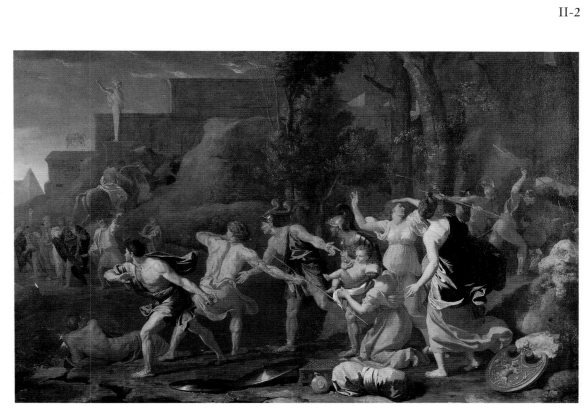

II-3

2. Horatius Cocles, by LE BRUN. 3. The Young Pirrhus Sauvé, by POUSSIN.

17

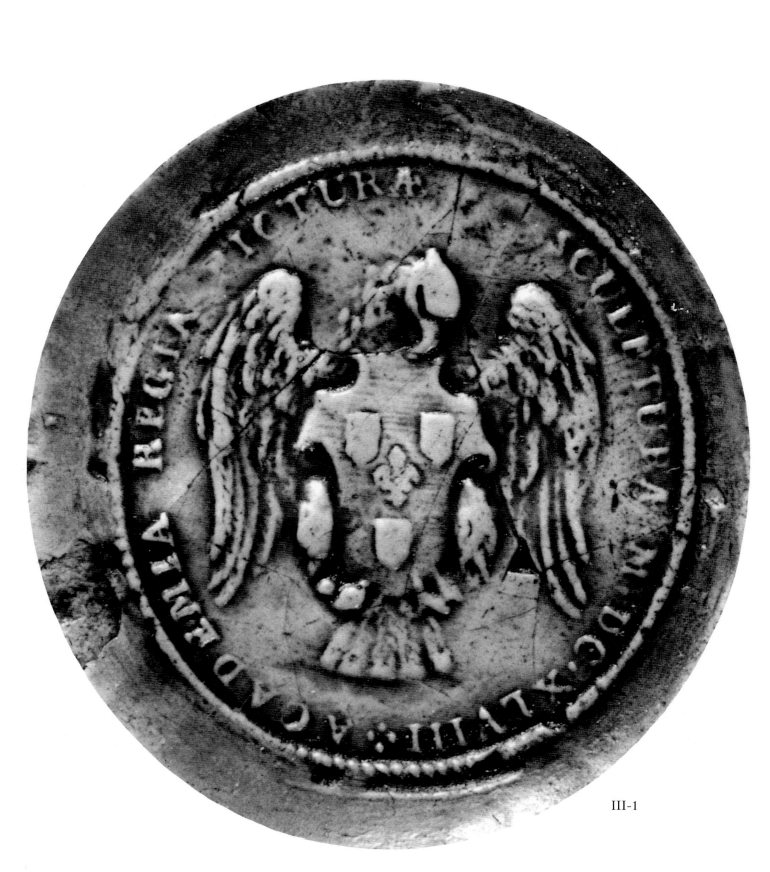

III-1

Seal of the Royal Academy of Painting and Sculpture MDCXLVIII

CHAPTER THREE

RETURN TO FRANCE
AND FOUNDING OF THE
ROYAL ACADEMY OF PAINTING

 L E BRUN arrived in LYON in January of 1646. Some months later in PARIS, he turned 27, "*with a heart full of enthusiasm and ambition, and aspirations of rising to the top. He possessed all the prerequisites for achieving his desire: his energy knew no bounds, he was an exceptionally hard worker endowed with a superior intellect, flexibility, skill, and above all a tenacious will that scoffed at obstacles or broke them down.*"[13]

During his absence from FRANCE, his protectors CARDINAL RICHELIEU and KING LOUIS XIII had both died. Since the King, LOUIS XIV, was only seven years old, his mother, ANNE OF AUSTRIA, had taken over control of the kingdom, naming CARDINAL MAZARIN as Prime Minister. Accordingly, religion held a preeminent position in the kingdom. It was at this time that the Queen Mother entrusted LE BRUN with the decoration of the CARMELITE CONVENT OF THE RUE ST- JACQUES.

LE BRUN found himself immediately appreciated by his entourage. He was thus overwhelmed with numerous commissions for decoration and religious paintings for churches such as SAINT-COME and SAINT-GERMAIN L'AUXERROIS as well as for the COLLEGE OF BEAUVAIS and the COLLEGE OF SAINT-SULPICE. CHANCELLOR SÉGUIER, his original patron, also comissioned several works.

LE BRUN's rising popularity among the nobility, the clergy and the artistic community gave him a privileged status. He took advantage of his fame to tackle certain ongoing problems within the artistic community. For several hundred years there had in fact been a bitter dispute between artists and craftsmen regarding the boundary between art and craft.

19

There was an organization known as LA MAÎTRISE consisting of judges who required that prospective members present a masterpiece in order to be accepted into the group. The jury members had such conservative and intransigent tastes and rules on the freedom of expression that any candidate who did not present a work conforming to its definition of art was not accepted. However, memberships were automatically granted to the sons of master craftsmen who were already members of LA MAÎTRISE. In addition, any painter in the King's service could be exempted from these conditions and had total freedom to practice his art for the King without having any of his works subjected to the jury's scrutiny. But,

> *"La Maîtrise insisted that when these privileged painters were not working in His Majesty's service, they were prohibited from practising their art, whether for the Church or for others, without the express permission of the judges, under threat of confiscation of their works, a fine of five hundred pounds and even exemplary punishment."*

Why did LE BRUN feel it necessary to found the ACADEMY? He could have automatically become a hereditary member of LA MAÎTRISE since his sculptor father was a man of the craft.

His motivation lay not in personal interest but in the name of ARTISTIC FREEDOM and of all artists regardless of their status. Therefore, after several lengthy arguments with various groups, LE BRUN decided to found the ROYAL ACADEMY OF PAINTING. The statutes of the corporation were drawn up with the consensus of supporters; to avoid any misunderstanding, it was clearly spelled out in the regulations that the crafts trades would be separated from the fine arts. There was even a rule in the statutes that called for the destruction of the distinctive insignia imposed by the craft guild. *"No act in the history of the French School of Painting can compare to this spontaneous resolution, which guaranteed the freedom of Art."*[14]

Circumstances hastened the foundation of the Academy. *"Two certified painters, Messieurs Levêque and Bellot, were attacked by the jury, which proceeded with a ruthless seizure of their works."* This was all it took for LE BRUN and his supporters to begin the process of obtaining Council approval for the ACADEMY. In 1648, the ROYAL ACADEMY OF PAINTING was founded with Crown approval. Its members were henceforth freed from any association with the craft guild.

Without any further delay, an academy school was proposed where anyone, regardless of his standing, could take courses in the painting techniques used by different artists. After having acquired certain skills, the pupils would be able to create their works in *total freedom* and to work for whomever wished to hire them without being governed by LA MAÎTRISE. On February 1, 1648, LE BRUN opened the doors to the school and gave its first lecture to a large audience composed of well-known personalities, artists, pupils and curious onlookers.

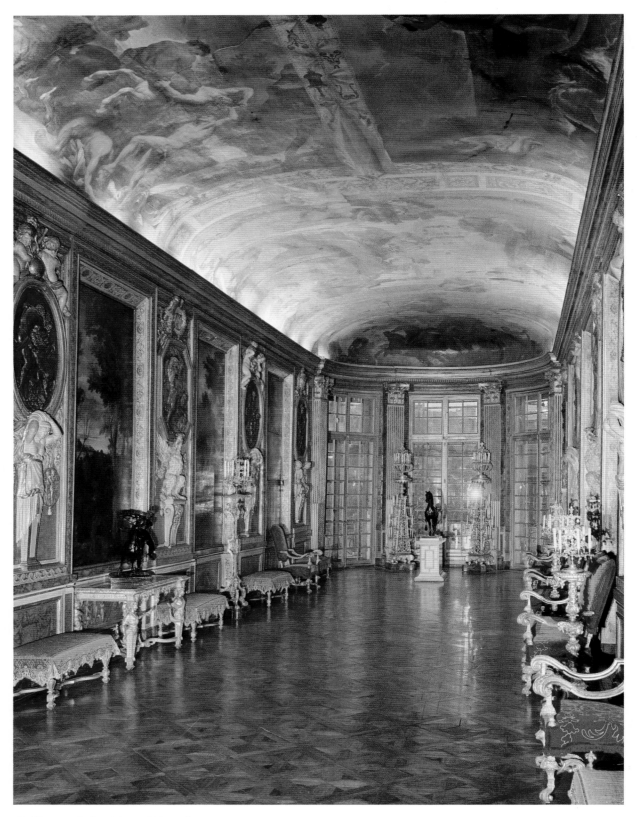

Gallery of the Hôtel Lambert IV-1

CHAPTER FOUR

PAINTER TO THE WEALTHY

 In the dozen or so years that followed, more and more of LE BRUN's works hung in the palaces and churches of PARIS. He was prepared to tackle all styles of decoration: whether it was a Biblical scene or a mythological subject, a historical scene or a portrait, each new work, however rapidly executed, was always the result of prolonged and circumspect thought. Though his hand was swift, it was always governed by careful deliberation.

It is no easy task to follow the career of such a master through all the manifestations of his genius in the period between the founding of the ACADEMY and his meeting with KING LOUIS XIV.

While commissions poured in from society's elite, from the nobility and especially from the wealthy, LE BRUN did not neglect his friends. An exhaustive list of works and important clients during this prolific period would be too lengthy to include here, but a few names should be mentioned: ANNE OF AUSTRIA, Queen Mother and widow of LOUIS XIII, sent for LE BRUN and told him of a dream she had had, asking him to translate it onto canvas. *"And Monsieur LeBrun penetrated the Queen's thoughts so well that when she saw the painting, she confirmed that it resembled that which she had seen in her dream."*[15] The painting, *Christ on the Cross Surrounded by Angels* was hung in the Queen's apartments in the LOUVRE. *"Anne of Austria rewarded the painter with a gold chain of great value and a diamond-studded watch."*[16]

The Queen, who was governing the kingdom during this time, commissioned several other works. As she was the benefactress of the CARMELITE CONVENT in the FAUBOURG

SAINT-JACQUES, she assigned LE BRUN the task of decorating the interior oratories. It was there that ABBÉ LE CAMUS, himself a benefactor of the monastery, became an admirer of LE BRUN and personally commissioned four celebrated paintings:

- *Meal in the House of Simon the Pharisee*
- *Christ Visited by the Angels in the Wilderness*
- *Saint Genevieve*
- *The Penitence of Mary Magdalene*

(It should be mentioned that *Meal in the House of Simon the Pharisee* is currently in VENICE as it was exchanged for PAOLO DE VERONESE's *Wedding at Cana,* now in the Louvre.)

Another of LE BRUN's devoted admirers was EVRARD JABACH, a great banker of German origin and principal director of the seventeenth century EAST INDIA COMPANY. According to NIVELON, the wealthy financier not only wished to acquire the painter's works but wanted exclusive rights to LE BRUN and offered him 20 pistoles per day along with the freedom to produce whatever he wished. But fate had other things in store for the great master.

There were other influential customers: DONGOY, Clerk of Parliament; the DUKE OF RICHELIEU; MARSHALL ANTOINE, the DUKE OF AUMONT; the MARQUISE OF PLESSIS-BELLIERE; the MARQUISE OF MONTGLAS; Président NICOLAS POMPONNE DE BELLIERE, who asked him to decorate the HOTEL DES PREMIERS PRÉSIDENTS DE LA COURONNE; JÉROME DE NOUVEAU, seigneur of FIENNES and *surintendant général des postes et relais de France,* who lived in one of the pavilions of the royal palace; OLIER, founder and first prior of the SEMINARY OF SAINT-SULPICE, where LE BRUN had decorated the chapel ceilings. (The prior, who had come to the chapel to watch the artist unveil the ceiling

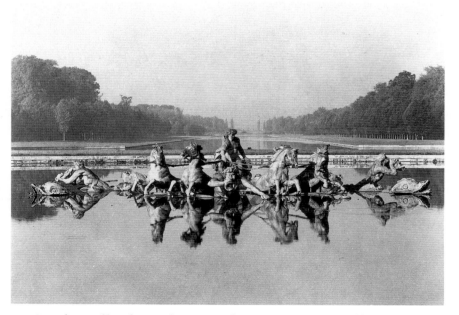

Basin of Apollo, from drawings by LE BRUN. Versailles IV-2

exclaimed, "*Sir, you are truly fortunate, to be able to wield your brush to produce such a beautiful expression of the glories of Heaven.*") Lastly, to conclude this partial list, there was NICOLAS LAMBERT, known as *le Riche*, who called himself LAMBERT DE THORIGNY, president of the Chamber of Accounts and owner of an estate on ILE ST. LOUIS.

LAMBERT DE THORIGNY called upon LE BRUN to decorate the largest room in his residence, a gallery whose ceiling was 68 feet long by 15 feet wide by 2.8 feet deep. The structure of the ceiling presented a serious problem to the artist in that it was too low for its length.

Vase, from drawings by LE BRUN. The gardens at Versailles IV-3

Only LE BRUN's talent could rectify this architectural asymmetry.

The situation called for exceptional caution in the arrangement of decorative masses, and LE BRUN rose to the occasion. He used all manner of tricks and resorted to artifice in order to give more height to his paintings. He took care to set each scene outdoors and gave his compositions a vertical thrust to fool the eye into seeing airy depths in the lifelike foreshortening and the magic of the heavens.

Three arcades divided the surface of the vault into four square caissons. These separated spaces presented an obstacle for the painter since they would break the unity of his composition and give the work a fragmented look. LE BRUN recognized the difficulty and envisioned placing flying figures directly under the arches, thereby linking the consecutive episodes of his legend. "*Through concerted effort and a skilfully designed plan, the painter was able to correct with incomparable artistry the defects inherent in the architecture of the gallery.*"[17] LAMBERT was thus able to sing the praises of his artist-decorator to the prestigious guests he received at his private residence.

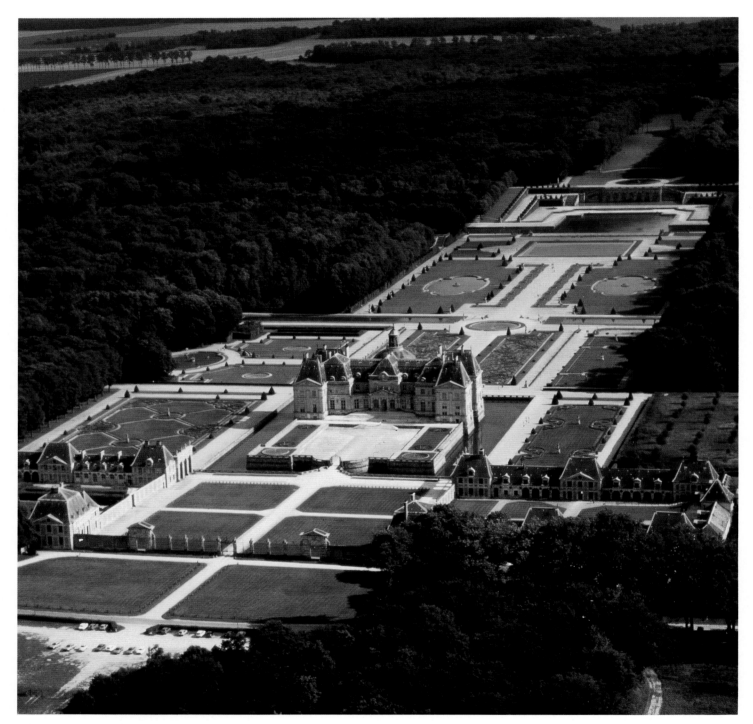

The Château of Vaux-le-Vicomte

CHAPTER FIVE

VAUX-LE-VICOMTE

Minister FOUQUET, Superintendent of Finances and Chancellor of the Exchequer, was among the visitors to LAMBERT DE THORIGNY's residence. LE BRUN's talent surpassed FOUQUET's expectations. Some time before, he had seen one of his murals in the refectory of the SISTERS OF ST. FRANÇOIS, near VINCENNES. He had been deeply moved by the qualities of the mural, which depicted the biblical scene of the Brazen Serpent. In LAMBERT's mansion, however, a completely different subject caught his eye: *The Arrival of Herçules on Olympus*. After seeing two works so different from each other, he recognized the richness and versatility of LE BRUN's genius and contemplated appropriating LE BRUN for his exclusive needs. [18]

The extravagant FOUQUET was already dreaming of his splendid new château at VAUX. He needed a First Painter, or better yet, someone to oversee all the paintings, sculptures, tapestries, landscaping, entertainment and nightime festivities that pervaded his fantasies. "*Neither Vouet, nor Poussin, nor Le Sueur could have carried his plans to fruition.*"[19]

Fouquet wanted to use art for his own glorification. LE BRUN, with his magnificent repertoire of allegories in the service of the all-powerful minister, was the perfect artist to create all of these glorious and triumphant works.

Hiring a painter was not for those of modest means, especially when that painter was LE BRUN. And yet FOUQUET, who usually provided modest accommodations for his artists, supplied a luxurious apartment for LE BRUN and his wife and paid him a generous pension of 12,000 pounds in addition to regular payments for each work that he produced. FOUQUET assigned him the task of decorating the CHATEAU OF VAUX-LE-VICOMTE.

LE BRUN commanded an army of 18,000 workers—regiments of sculptors, painters, cabinetmakers, gilders and tapestry-makers—who laboured to produce an opulent masterpiece never before seen in FRANCE. In four years FOUQUET spent over 18 million francs realizing his dream, at a time when the total annual revenue of the French treasury was barely 30 million francs and supported not only the King but the army and the entire administrative apparatus of the State. It is hard to imagine a more scandalous situation: half of the

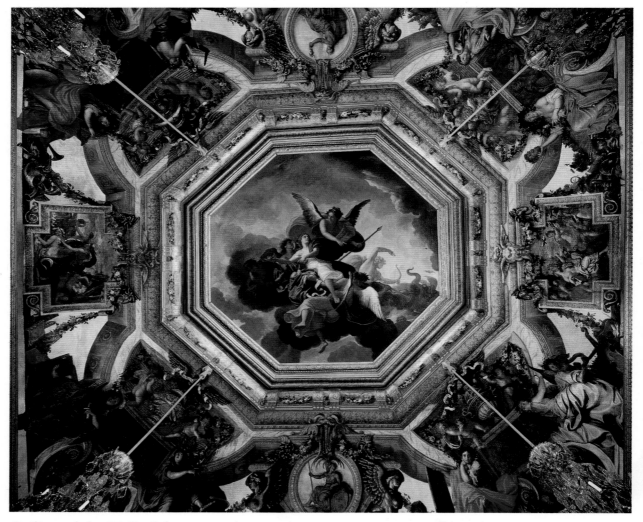

Ceiling of the Hall of the muses, by LE BRUN

V-2

country's annual revenue was being funnelled into building the personal residence of the Minister of Finance.

When everything was ready, FOUQUET arranged festivities in honour of LOUIS XIV to celebrate the completion of the château and he chose LE BRUN to orchestrate this gala reception. He used his artistic genius to make this the greatest living work of art that FRANCE had ever known.

On August 17, 1661, LOUIS XIV, the Queen Mother, ANNE OF AUSTRIA, the COUNTESS OF ARMAGNAC, the DUCHESS OF VALENTINOIS, and the COUNTESS OF GUICHE, along with all the court dignitaries, arrived in the Court of Honour. The guests strolled through the château, marvelling at the richness of LE BRUN's decoration. Nymphs, herms, and statues were set in motion to begin the spectacle; boulders opened up to reveal other nymphs.

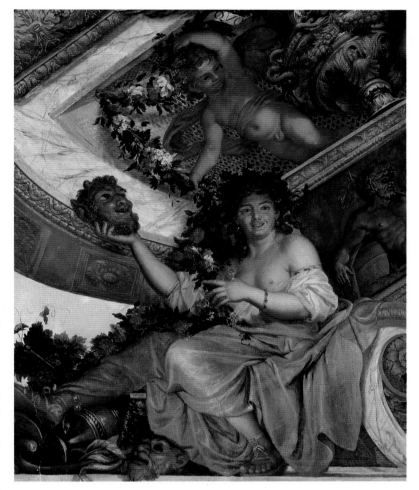

Detail of preceding photograph V-3

Hundreds of jets of water swirled to the sound of music and hundreds of torches lit up the magnificent gardens; MOLIÈRE had even written a play especially for FOUQUET's guests.

Dinner was served: a feast of quail, bunting and pheasant presented on a gold and silver table service to some 7000 guests. Even the King was not wealthy enough to dream of such a spread and although he was dazzled by the grandeur of the reception, he was already prepared to have Fouquet arrested on the spot.

Certain historians report that the King whispered to the Queen Mother, "*Mother, shall we make these people disgorge?*" - "*No*", she continued, "*it was incorrect for a guest to arrest his host in his own home.*"

La Béjart, representing a household nymph, sprang out of a shell with an tribute to the King composed by PELLISSON. Next, there was a comedy, followed by a ballet and *"finally, a dazzling exhibition of fireworks drew interlaced L's for Louis in the night sky."*

The poet JEAN DE LA FONTAINE bestowed all the honour of this lavish evening on LE BRUN:

"C'est LeBrun, par qui Vaux embelli.

Présente aux regardants mille rares spectacles:

LeBrun dont on admire et l'esprit et la main,

Père d'inventions agréables et belles,

Rival des Raphaels, successeur des Apelles,

Par qui notre climat ne doit rien au Romain"[20]

At Vaux, t'was Lebrun, the grand orchestrator
With a thousand rare sights he thrilled the spectators
We admire the skill of his hand and his mind
Engendering works both gay and sublime
He is Raphael's rival, our Apelles here at home
Thanks to him our climate owes nothing to Rome.

Such was the elegant praise that LA FONTAINE addressed to LE BRUN. He had truly achieved the objectives that FOUQUET had set out for him.

The King was astounded by the ostentatious magnificence of the display and outraged by FOUQUET's king-like demeanour. Some weeks later, the King dispatched D'ARTAGNAN and his musketeers to arrest FOUQUET, who was to die in his prison cell 19 years later. Ironically, it was at VAUX that LOUIS XIV first became aware of LE BRUN's incredible genius. After FOUQUET's arrest, the King immediately took LE BRUN into his own exclusive service. LE BRUN had already laid the groundwork for the style that would become the inspiration for the future palace of the SUN KING at VERSAILLES, **THE STYLE** we know today as LOUIS XIV.

Ceiling of the Cabinet des jeux V-4

Another poet, LORET, heaped praise on LE BRUN's productions at VAUX-LE-VICOMTE following FOUQUET's evening of festivities:

"Lundi dernier traita la cour

En son délicieux séjour,

Qui la maizon de Vaux S'appelle.

Où LeBrun, de ce temps l'Apelle,

A mis (je ne le flate point)

La peinture en son plus haut point,

Soit par les traits incomparables,

Les inventions admirables,

Et les desseins miraculeux

Dont cet ouvrier merveilleux

Délicatement reprézente

L'inclination excellente

De ce sage seigneur de Vaux

Qui, par ses soins et ses travaux,

Ses nobles instincs, ses lumières,

Et cent qualitez singulières,

Se fait aimer en ce bas lieu

Presque à l'égal d'un demy-dieu"[21]

Last Monday evening the court was received
In that lavish abode we all know as Vaux
Where Charles Le Brun, who is our Apelles,
Has exalted painting to summits divine
With exquisite inventions and miraculous designs.
(These are not idle flattering lines!)
This superb worker did delicately mould
The fine inclinations of the Seigneur of Vaux
Into graceful creations; his instincts so worthy
His uncanny brilliance, and his myriad virtues
Have made him revered in this earthly domain;
He is almost a demi-god, such is his fame.

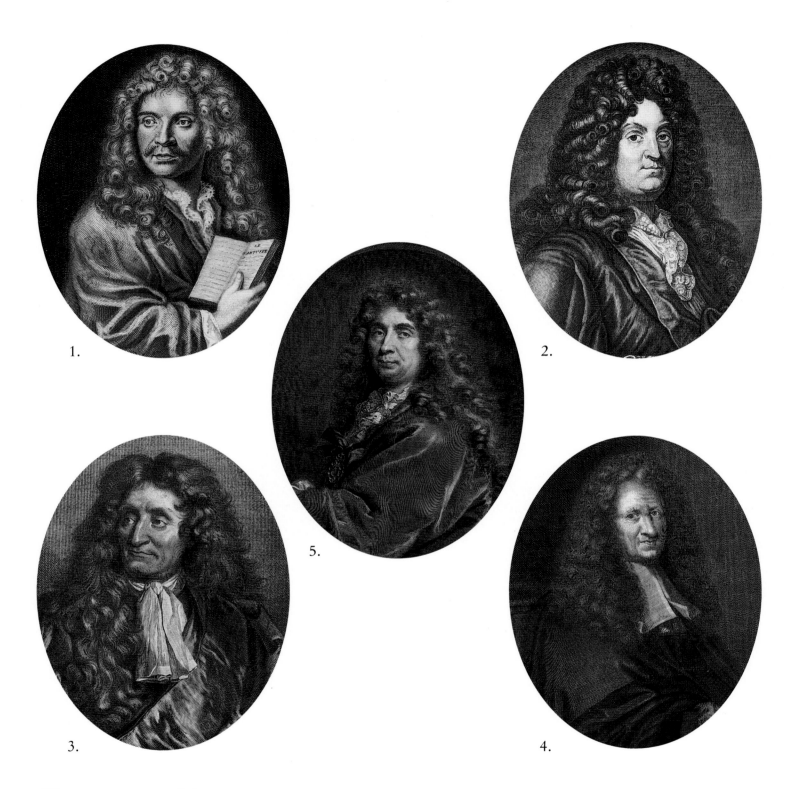

The great century of the art.
1. MOLIÈRE. 2. RACINE. 3. LAFONTAINE. 4. CORNEILLE. 5. LE BRUN.

CHAPTER SIX

FIRST PAINTER TO HIS MAJESTY KING LOUIS XIV

 LE BRUN had already worked for LOUIS XIV before entering his exclusive service. In 1660, at the royal palace of FONTAINEBLEAU, the King had commissioned a composition based on the story of ALEXANDER. LE BRUN had painted ALEXANDER and HAEPHESTION entering the tent of DARIUS. This painting, *The Queens of Persia at the Feet of Alexander*, hung in the LOUVRE. VERONESE had already depicted this subject in *The Family of Darius* but LE BRUN had no fear of comparisons and his desire to outdo the great Venetian inspired an admirable composition.

Each day, the King and his courtiers came to watch LE BRUN work on the new canvas. The artist amazed the King with his prodigious speed at rendering the figures in the composition. "*The courtiers identified Louis with Alexander the Great, and thus they admired and revered the painting.*"

Though LOUIS XIV turned 23 in 1661 he had not yet ruled the kingdom. During the eighteen years following the death of LOUIS XIII, MAZARIN had absolute control over the kingdom's affairs. The Cardinal had already met LE BRUN at VAUX. Charmed by his great versatility, he had commissioned a painting depicting the Triangle of Maxence. LE BRUN once again found himself being compared to a famous master, this time RAPHAEL. "*Mazarin was enchanted by the work and became LeBrun's patron; it was Mazarin who presented LeBrun to the Queen Mother*", who was also one of his admirers, as described previously.

With MAZARIN's death on March 9, 1661, the young LOUIS XIV decided to take state matters into his own hands. He broke with tradition and abolished the office of prime minister. All decisions and appointments would henceforth come from him; it was at this moment that he addressed the Council with the famous words, "L'ÉTAT, C'EST MOI (I am the State.)" He assumed total control of finances and put the state treasury at his disposal in order to realize the most pompous productions FRANCE had ever known. Lasting 54 years, the reign of LOUIS XIV would prove the longest and the most culturally rich, a reign which will be forever marked by the greatest minds of French culture.

The King spent astronomical sums of money with ostentatious ease to assemble the very best that great art had to offer. Thus he took into his service MOLIÈRE, as actor to the King; RACINE, as playwright; CORNEILLE, as historiographer to the King; LA FONTAINE, as First Poet, and finally, CHARLES LE BRUN, as First Painter to his MAJESTY KING LOUIS OF FRANCE.

It was undeniably a high point in French cultural history and one can well imagine the importance of the culture surrounding the life of the First Painter of the kingdom. As HENRY ROUJA of the *Académie Française* would later remark, "*he had the distinction of being great in a century where everything was great and to be endowed with genius at a time when genius was everywhere.*"[22]

LE BRUN assumed the functions of *First Painter* in 1661 (although he did not officially receive the title until 1664). In December 1662 the King made him a titled *Nobleman.* The actual letter reads: "*We wished to bestow on Sieur LeBrun, our First Painter, a mark of the esteem that we hold for him and for the excellence of his works, which, it is universally acknowledged, outshine those of the famous painters of the last centuries.*"[23]

The King's action amounted to a public declaration of LE BRUN's superiority over POUSSIN, VOUET and all other well-known painters. It was heady praise, and the King was careful to point out that it was "*universally acknowledged.*" These words reflect the all-powerful master's incontestable superiority, but this was certainly not a unanimous opinion since the First Painter came under some criticism from sworn enemies. But what great man has not seen his fame sullied or maligned by the underhanded actions of his adversaries?

The historian JOUIN later confirmed that *"if the truth be known, the new king placed more demands on his First Painter than his father had, and neither Vouet nor Poussin himself would have proven obedient enough to allow Louis XIV to guide his hand . . ."*[24]

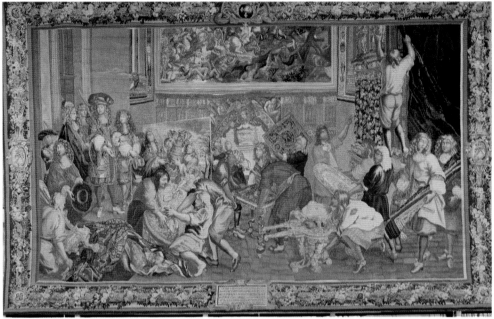

Tapestry: Louis XIV visiting the Gobelins VI-6

Other appointments followed: LE BRUN became *Rector of the Royal Academy of Painting.* The King then named him *General Custodian of Paintings and Drawings* with the mission of procuring all paintings and sculptures that he felt to be worthy of enriching the royal collections.

In 1663, the GOBELINS manufactory was founded primarily to satisfy the King's private needs. The Gobelins family had been dyers for centuries and their small dye works already existed in 1663. But it was only when LOUIS XIV assigned the manufacture of the Crown's tapestries and furniture to this modest factory that the GOBELINS name gained true renown. It can therefore be said that the date that the GOBELINS was established as the CROWN'S MANUFACTORY coincided with the date that LE BRUN was named as its director.

THE GOBELINS produced tapestries, furniture, silver- and goldwork, locks, mosaics and marquetry for the King. As director of GOBELINS, LE BRUN *"assembled the best artists —painters, sculptors, gilders, metal casters, tapestry-makers, and gold- and silversmiths— so that each work would convey all the glory, opulence and richness of the Sun King's reign. Everything that was manufactured in the kingdom was based on LeBrun's sketches and drawings."* He wielded strict control over the artists so that everything conformed to his ideas and to those of the great monarch and thus invented the LOUIS XIV STYLE evident in all GOBELINS productions.

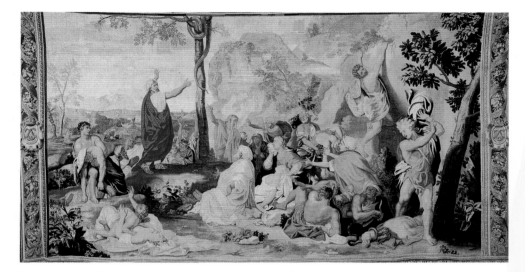

Tapestry: The Brazen Serpent VI-7

It is estimated that over 250 workers were employed in the tapestry workshops alone, which gives a good indication of the magnitude of the operations. LE BRUN decorated the King's palaces, the LOUVRE, the GALLERY OF APOLLO, VERSAILLES, the TUILERIES, the King's carriages and even his naval vessels.

The following excerpt from the pages of the MERCURE GALANT, a newspaper of the time, gives a more detailed description of LE BRUN's duties at GOBELINS: (25-26)

"We must not regard Monsieur LeBrun as a mere painter; the breadth of his genius touched everything; he was inventive, he was learned, he knew the history and customs of all peoples and his tastes were as cosmopolitan as his knowledge; in one hour he could direct the work of an infinite number of workers. He gave his plans to all of the King's sculptors, and all of the gold- and silversmiths; those candelabras, those great basins adorned with bas-reliefs representing the King's history were all based on the designs and models that he made. He also contrived the decoration of entire apartments; with his vast knowledge of history, he had a perfect understanding of allegory. While legions of workers executed his designs, there were also countless others who did nothing but weave tapestries according to his plans. He confected those of the Battle and Triumph of Constantine, those of the history of the King and of Alexander, those of royal houses and of the Seasons, the Elements and a host of others. We can conclude that every day he put thousands of hands to work and that his genius was universal . . .

Though I have cited many of his works, I neglected to speak to you of those grand and superb cabinets that were manufactured at Gobelins according to his designs and under his supervision. It seems that each of the arts made their contribution there. We have seen many of them in the gallery of the Tuileries and in the Gallery of Apollo for all of these cabinets have their name and their history. Finally Monsieur LeBrun's appeal was universal; to this I can bear witness for I saw very astute foreigners examining the locks and bolts of the doors and windows at Versailles and the Gallery of Apollo at the Louvre as if they were masterpieces whose beauty they could not help but admire.

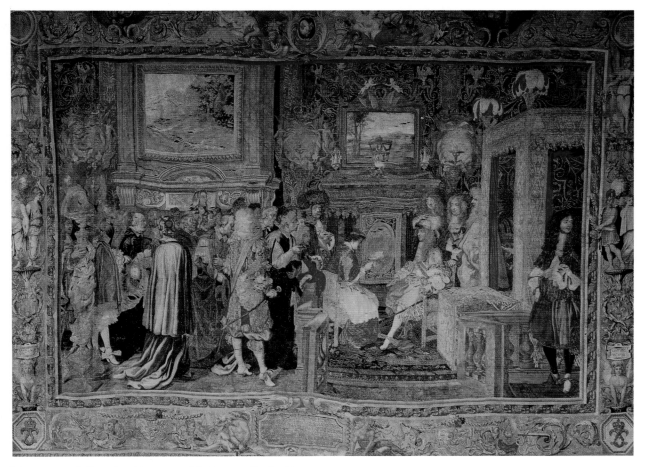

Tapestry: The Audience of Légat. Gobelins VI-8

Let us not forget the famous carriage that Louis XIV offered to the Great Mogol in the aim of encouraging the endeavours of the East India Company. It was at Gobelins that this royal gift was produced and Monsieur LeBrun, writes Guillet, was chosen by Monsieur Colbert to make the drawings, both for the construction of the carriage and for the different ornamental sculptures and metalwork which adorned it."

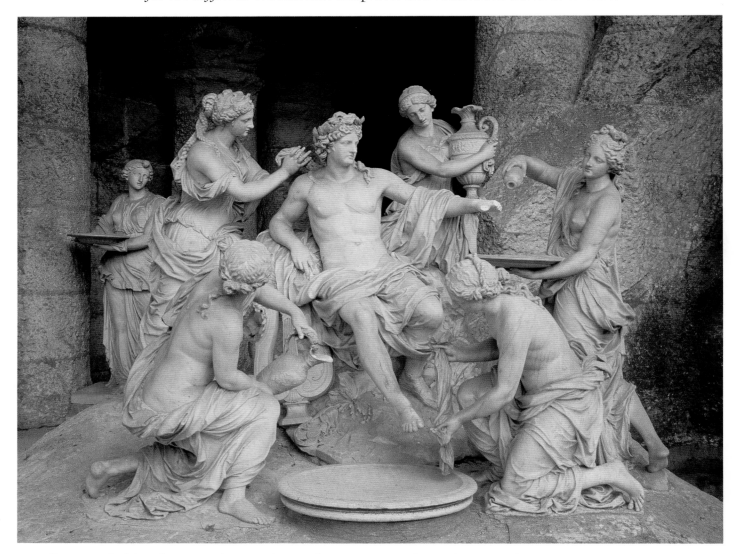

Apollo attended by the nymphs. Sculpture by GIRARDON, from drawings by LE BRUN VI-9

The following list by JOUIN provides information on LE BRUN's principal collaborators at GOBELINS [27] :

How can we attempt to remember LeBrun's countless collaborators? The battle painter Vander Meulen was the director's first lieutenant. Then there was the floral painter Monnoyer, Baudouin Yvart, Houasse, the two Boullongues, Arvyer, Henri Testelin, who were joined by the two Corneilles, Noel and Antoine Coypel, the animal painters Boel and Nicasius Bernarerts, the marine painter Montagne, Poerson, Nivelon, Verdier, the de Sève brothers, and more than forty others. There were the sculptors Coyzevox, Auguier and Tuby, the engravers Le Clerc, Audran and Rousselet, the furniture makers Philippe Poitou, Domenico Cucci and Philippe Caffiéri, the goldsmiths Alexis Loir, Claude de Villers and Dutel, the lapidaries and mosaic artists Gachetti, Branchi and Horace and Ferdinand Megliorini, the Dutch tapestry makers Jans and his son. There was also Henri Laurent, Pierre and Jean Lefebvre, Jean de la Croix and Mozin (both Flemish), the embroiderers Simon Fayette and Philibert Balland. The dyeworks was operated by the Dutchman van der Kerchove. It is estimated that there were more than two hundred and fifty workers in the tapestry works alone.

It is not surprising that with such a staff, the Gobelins overshadowed all the other manufacturing centres in the kingdom, even the workshops of the Louvre. These however continued to produce remarkable works. One has just to remember that Germain, Claude Ballin, the peerless cabinet maker Boule and Narin, the director of the medal works, stayed at the Louvre. But the First Painter's influence was at times felt even here, notably when they were assigned the furnishing of Versailles or Marly, as was very often the case for Claude Ballin.

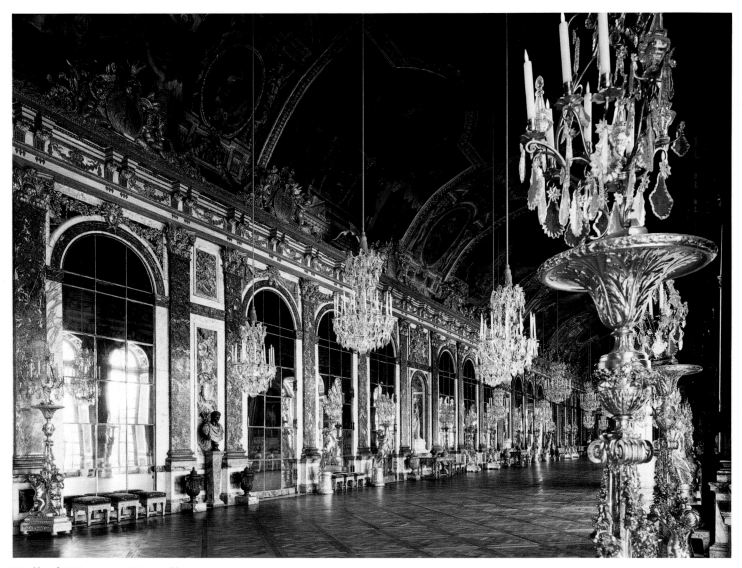

Hall of Mirrors. Versailles

VII-1

CHAPTER EIGHT

THE FINAL YEARS

For fifty years, CHARLES LE BRUN's rise had been unrestricted. He enjoyed glory, happiness, wealth, and had friends everywhere. Some biographers maintain that this was the era in which the King, the Minister and the First Painter formed an admirable and uncommon triumvirate. "*Louis XIV, a proud sovereign whose dream was to leave behind immortal renown and who was incapable of petty tastes. Colbert, a brilliant minister and administrator, clever enough to dispense untold millions to artists. Le Brun, a painter astute enough to understand the desires of his patrons, and powerful enough to bring all of his contemporaries under his control. Such is the legacy left to the history of art by this trio of the second half of the seventeenth century.*"[46]

On September 6, 1683, tragedy dealt a terrible blow to LE BRUN's career. His benefactor, COLBERT, died, and was succeeded by the MARQUIS OF LOUVOIS.

On the surface, nothing seemed to change. LE BRUN was no less attentive to the new minister's needs, and was as respectful and as eager to serve as ever. But LOUVOIS was of a different temperament than COLBERT; he despised his predecessor and detested anyone who had been his friend or protegé. LE BRUN's very position made him a prime target for the Minister's rancour: despite his courtesy, he was snubbed and treated with scorn. Moreover, LE BRUN's mortal enemy, the painter MIGNARD, was busily launching furtive attacks from behind the Minister. He had waited for forty years to settle old scores. His first invectives had been launched against the founding of the ACADEMY OF PAINTING. He belonged to the group that opposed the freedom of artists and supported LA MAITRISE. But what in fact lay behind these renewed and often perfidious attacks against the ACADEMY by an ineffectual

man, who, when the time was ripe, intended to the take over the office formerly held by LE BRUN as the head of this same ACADEMY?

As Superintendent of Buildings, LOUVOIS attempted, without the King's knowledge, to depose LE BRUN by denying him any new decorating contracts. Despite this, the First Painter continued with his decorations in the HALLS OF PEACE AND WAR at VERSAILLES and completed them in 1686. He never wanted for work—on the contrary, he had too much of it—but what disheartened him was being held in disgrace by a highly placed person. During the year that COLBERT died, LOUVOIS tried to attack LE BRUN at the ACADEMY, thinking that given the choice between a painter and an all-powerful minister, the members of the ACADEMY would chose the Minister. LE BRUN gave up his functions of *Chancellor* and *Rector* under the pretext of not having enough time to devote to them. In reality, he was aware of the hostility threatening him and hoped to obtain a new mandate through re-election. This tactic was so successful that his colleagues gave him the new title of *Director* in addition to his being re-elected to the positions of *Chancellor* and *Rector*. This humiliated LOUVOIS before the entire ACADEMY and only served to fuel his animosity.

The malicious minister escalated his perfidious attacks. LOUIS XIV was too noble to get involved in such an intrigue and was unaware of the sordid plot against his First Painter, especially since LOUVOIS could hardly conduct such an underhanded war against the artist out in the open. That would have amounted to telling LOUIS XIV and his court that they had been wrong for more than 25 years. Discretion was therefore essential in these confrontations.

In spite of this, the King continued to hold his First Painter in the same high esteem; in 1685, he interrupted a Council meeting to take delivery of a new painting entitled *The Crucifixion* which he received with a great deal of enthusiasm. In 1686, the artist offered the King canvases depicting *Jethro's Daughters* and *Christ on the Cross Surrounded by Angels*. As the Dauphine was hurrying by, the King stopped her in front of the paintings, wanting her to share his delight. He then remarked that people had a habit of always waiting for a painter to die in order to do justice to his brilliance. Turning to LE BRUN, he added graciously, "*You needn't hurry to die in order to make your paintings valuable. I already value them highly as it is.*"(47)

CHAPTER NINE

CONCLUSION

What is remarkable about CHARLES LE BRUN is that he was a highly acclaimed painter, who, over the course of years gained importance as a historic figure in the reign of LOUIS XIV. A look in almost any book on the history of FRANCE will reveal that LE BRUN is the only artist and painter frequently mentioned for his historic accomplishments. The institutions that he founded or developed have survived for centuries; the CABINET DU ROI, known today as the LOUVRE, houses many well-loved canvases and drawings from the collections of MAZARIN, FOUQUET and JABACH, which were either chosen by LE BRUN himself or acquired upon his recommendation. The ÉCOLE ACADEMIQUE became the ÉCOLE DES BEAUX ARTS, and the GOBELINS factory continued as the national tapestry manufactory for hundreds of years. The ACADÉMIE DE FRANCE À ROME also remained intact for centuries. *"He was above all the first French artist to achieve success abroad, and the worldwide prestige enjoyed by French art for nearly two centuries had its origin in his era."*[(49)]

LE BRUN's greatest personal triumph lay in *"separating the artist from the artisan, the man of inspiration from the tradesman, masterwork from handiwork. LeBrun was the liberator who broke the tethers in which artists had felt deprived of initiative and dignity."*[(50)]

LE BRUN succeeded in obtaining important positions and achieving fame and glory not because of his outstanding administrative talents but because of his outstanding talent as a painter. As a youth he so impressed SÉGUIER with his precocious talent that the Chancellor took him under his wing. The Queen Mother, the Pope, the cardinals, financiers and bankers were looking not for a foreman to coordinate large projects but an artist whose works would be appreciated. LAMBERT chose LE BRUN to decorate the gallery in

his residence because he felt that he was the only artist capable of correcting the built-in architectural flaw.

Later, FOUQUET chose LE BRUN because he was fascinated by his gift for treating very different subjects with equal ease. LOUIS XIV then made the artist his First Painter. Such success is understandable simply by the fact that in LE BRUN's time a painter had to be a great artist if he wished to be a very good decorator. This stands to reason, since the decoration of a home has a profound effect on those who live there; it influences their feelings, and their relationships both with others and with themselves. In short, it is a question of state of mind and LE BRUN was able to get inside the minds of the great personalities of his century. To accomplish this, he needed complete mastery of his art in order to be able to adapt each work to its owner.

This is why the *Battle of Arbella*, dedicated to LOUIS XIV, and *Christ on the Cross Surrounded by Angels,* dedicated to the Queen Mother, seem to be the work of two different artists. For LE BRUN, painting was a tool that served to convey a non-verbal message from within. Like the deaf, the figures in his paintings communicate through gestures and facial expressions. With a thorough understanding of customs, symbols and the rules of etiquette, one can interpret the messages conveyed by the gestures of the body, the head or the feet. Minute historical or archaeological details can shed much light on what is being communicated in the painting.

After three centuries of exposure to light, humidity and dust, LE BRUN's unrestored works have become faded and dull. Fortunately these effects are secondary; figuratively speaking, the text remains legible and all of the richness of the painter's genius can still be appreciated. Yet who among the thousands of museum visitors could explain the circumstances surrounding the suicide of CATO (*Death of Cato*) or the huge eagle hovering above Alexander's head (*The Battle of Arbella*), or why the woman in the foreground is not bowing down towards Alexander, an apparent error in perspective in *The Tent of Darius*. Who among the tourists could explain the circumstances surrounding Jepthe's preparations to kill his daughter (*The Sacrifice of Jepthe*)?

Very few people could offer interpretations of these paintings. Since LE BRUN's art transcends the visual, it holds little interest for anyone concerned only with superficial

impressions. Only scholars or those educated enough to interpret these works are fascinated by their richness of expression. AN UNDERSTANDING OF LE BRUN'S PAINTINGS REQUIRES THE SAME INTELLECTUAL EFFORT AS THE PAINTER PUT INTO PRODUCING THEM, which explains his unpopularity in the centuries following his death. Indeed, French painters seem to have abandoned the academic tradition and spiritual effort since the eighteenth century.

LOUVOIS, COLBERT's successor and sworn enemy of LE BRUN, greatly undermined the painter's posthumous popularity. He issued an order to affix seals to all of the painter's works and drawings, under the pretext that all of the First Painter's work should be dedicated to the King alone. As a result, virtually none of LE BRUN's works can be found outside of FRANCE, but this in no way diminishes the artist's greatness. The King had declared him "*the greatest French artist of all time*".

While such a declaration may seem bombastic, the fact remains that no other French painter produced as much magnificent decorative work. No other French painter founded as many great institutions such as the ACADEMIE ROYALE, the ACADÉMIE DE ROME and the ACADEMY SCHOOLS. No other French painter launched a movement that was to last a century. No other French painter succeeded in holding on to first place for such a long time without being unseated. Finally, no other French painter put so much passion into works such as the *Allegories of the Sun King* and the enormous canvases depicting *the Battles of Alexander*. Other painters have certainly accomplished some of these things, but who else could be named who has achieved them all?

LE BRUN was not satisfied "*to tackle only artistic problems, but also to create with other artists, adapting himself to their work and living with constant threats to his power. In 1642, Poussin rejected the challenge; in 1661, LeBrun accepted it and succeeded.*"[51]

LE BRUN was the sole author of his achievements. His future was not mapped out by his sculptor father. He did not owe his success to his titles, which obliged the artistic community to hold him in esteem. Some historians have argued that LE BRUN was a despot who used his power to exert artistic tyranny over the seventeenth century. This is an absurd claim with no factual documentation. It is worth pointing out that LOUVOIS was ridiculed by the ACADEMY when LE BRUN was re-elected as director despite the minister's threats.

Whenever LE BRUN sensed the slightest controversy surrounding any of his positions, he resigned and gave people the chance to express their wishes in a new election, winning re-election each time. Even after his death, the ACADEMY continued to honour him; no subsequent director of the ACADEMY received as much attention.

A year after LE BRUN's death, JOSEPH CHRISTOPHE, a student of the school, "*had the temerity to complete and retouch one of the late Monsieur LeBrun's works that depicted the meeting between Bacchus and Ariane at Naxos;*" as punishment for his insolence, he was "*excluded forever from entering the Academy and the judgement was posted in the school to serve as an example.*"[52]

LE BRUN had thus been venerated by the highest artistic authorities and had enjoyed the favour of the greatest king in Europe during a regime in which art reigned supreme. If a great man is judged by the greatness of his accomplishments, there can be no doubt that the praise that LOUIS XIV had for LE BRUN reflects a certain realism. Great artists of such prolific output were extremely rare, and their likes have not been seen for a long time.

> "*Who today knows how to complete an avenue or decorate a square, how to achieve harmony between a building and the landscape, between a sculpture and a wall, between colour and materials? Each artist feels his way along, eyes closed to better express himself, protectively completing his little work, satisfied to be able to display his statue on a lawn or his fresco in a hallway. We believe that new materials should lead to new harmonies, yet we do not know what they are. This was the marvellous talent of LeBrun, which occurs only in art's greatest eras.*"[53]

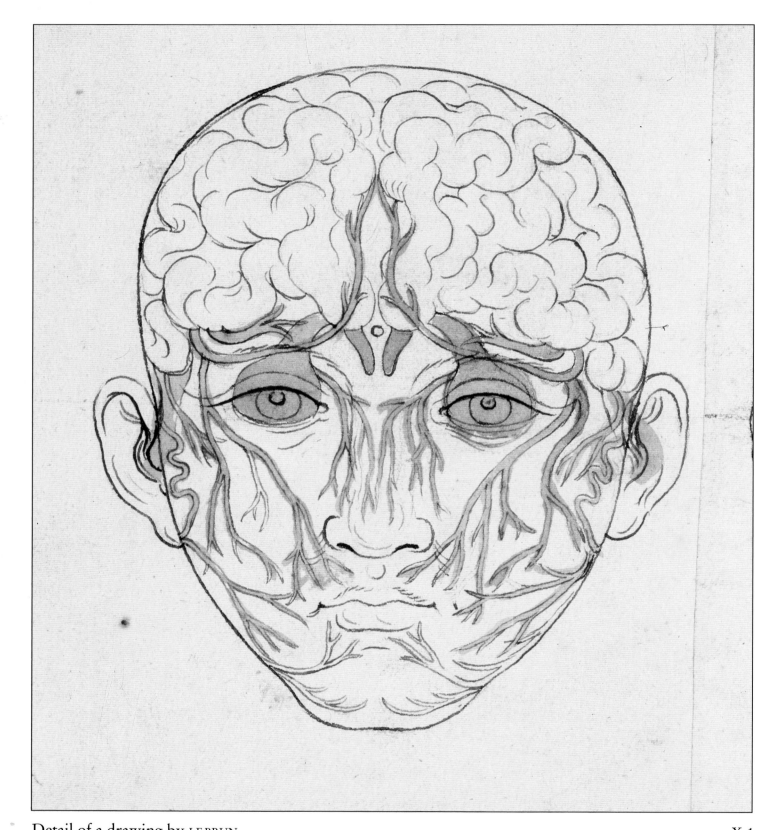

Detail of a drawing by LE BRUN

X-1

LE BRUN'S TECHNIQUE

 It should first of all be noted that at the height of his career, LE BRUN used a classical painting and drawing technique that was consistent and highly systematic. Although he was a great believer in the freedom of artistic expression, he was nevertheless bound by a maze of laws covering anatomy, ratios, the vocabulary of colors, rules of etiquette and specific symbols. In addition, based on his personal interpretation of human emotions he established measurements for the distortion of the facial features under the influence of the passions. He also devised his own system of geometry for lighting and the telescoping of planes.

Hundreds of LE BRUN's drawings have been stored in our ultrahigh-definition computers, thereby enabling specific comparisons to be made by enlarging or reducing details, reversing them, spreading them out, superimposing them or integrating them into a painting. The process is long and rigorous but the results are conclusive: whether it is a drawing of fingers, phalanges, feet, or even the posterior cubical muscle or the joint of the epicondyle of the humerus, the measurements of the distortion of the facial features under the influence of the passions, the chemical pigmentation of the colour, the brush marks, or the sequence in which the layers of paint were applied, LE BRUN's techniques produced unique results. It is therefore always possible to detect in a copy discrepancies in the application of the fundamental principles as established by the founder of the ACADEMY.

The purpose of this work is not to dwell on these specific characteristics, which could themselves form the focus of an entire book. Moreover, three centuries of exposure to light, humidity and dust, as well as numerous restoration efforts have left certain

Charles LE BRUN, Anatomical Study. Paris, Louvre X-2

concepts less apparent to the eye. Instead, we will attempt to introduce the reader to the specific process which underlies LE BRUN's work and which demonstrates a distinct sense for carefully conceived painting.

During LE BRUN's lifetime there was an ongoing debate between the followers of POUSSIN and those of RUBENS, which was known as the Quarrel of Colour and Design. Poussinists felt that form and design were of the highest importance, whereas Rubenists were fascinated by the use of colour to delight the eye and accorded little importance to the spiritual. LE BRUN was able to settle the matter once and for all by declaring that the intellect had to be satisfied first, but without neglecting the visual aesthetic. He chose the middle path in an argument that was often taken over by zealous extremists.

The fundamental basis for LE BRUN's art can be summed up in the following two points: "*Raphael taught the purest form of drawing, Corraci the most exquisite grace and Titian the most lavish colour. Since perfection had already been attained, all that was left was to use it in order to further the art of self-expression.*" In the words of a poet: poetry is the great art of expressing profound thoughts with simple words that already exist. For LE BRUN, painting was like a poem whose richness lies in the value of its message.

The first step in producing a painting was choosing the subject. Almost all of LE BRUN's paintings tell a story, whether ancient or contemporary, religious or mythological. Since he worked almost exclusively on commissions for ministers, kings or bishops, who

provided him with the subject, he rarely drew on his own imagination for subject matter. Many of the paintings done prior to 1661 depicted biblical scenes, since several of LOUIS XIII's ministers, notably CARDINALS RICHELIEU and MAZARIN, were religious leaders. In 1661, LOUIS XIV took sole charge of the kingdom and commissioned paintings of battles such as those in the ALEXANDER series. They were followed by the allegorical paintings depicting a triumphant LOUIS XIV in his own battles. LE BRUN's own style is most evident in the works from this period. At the peak of his career, with total freedom of expression and unlimited resources, he undertook huge canvases dominated by conquering warriors in magnificent helmets and armour. Towards 1678 he completed the final work in the GRANDE GALERIE at VERSAILLES. In the years that followed he returned to biblical sources as the King's exploits lost their glory and the kingdom's fortunes declined. After 1683, religion became a daily topic at the meetings of the King's council, which explains why LE BRUN's paintings took a decidedly religious slant in the final years of his career.

Once the subject matter had been chosen, LE BRUN considered the project from a decorator's perspective. The shape, size and colour of the painting were all important considerations, since they were most often created for a specific location in the client's residence. LE BRUN's canvases were often very large since his well-to-do clients had huge apartments.

Although he did produce a few portraits for wealthy clients, as a rule LE BRUN did not paint portraits, still-life or landscapes. He was of the opinion that it was somewhat foolish to copy a landscape onto canvas since this did not require the slightest intellectual effort. *"LeBrun believed that painting was a serious and fundamentally literary discipline, a liberal art whose rightful place was next to poetry, theatre and rhetoric."* (54)

The second stage in the process formed the very core of LE BRUN's art. Before preparing his paintbrushes and pencils, he conducted painstaking research in his books and notes in order to find the information he needed to made his composition authentic. He constantly consulted the works of HESIOD, VIRGIL and HOMER, as well as the OLD and NEW TESTAMENTS. He also devoted much time to the study of symbols, protocol and customs, which enabled him to add subtle elements to the carefully conceived narration of his composition.

The painting on the opposite page is an allegorical depiction of LOUIS XIV conquering the region of FRANCHE-COMTÉ. BESANÇON was one of the towns besieged by the King's troops in 1674. It is located on a bend in the DOUBS RIVER and became the capital of FRANCHE-COMTÉ. We will first take a look at how LE BRUN's symbolic language reveals his profound sense of culture and of the mind.

THE INTERPLAY OF SYMBOLS

1. Louis XIV, in full military regalia, holds in his right hand a commander's staff that he plants in the vanquished DOUBS.

2. He looks at a soldier symbolizing TERROR, who wears a helmet in the form of a lion's muzzle, and holds a dagger.

3. The weeping women grovelling at his feet symbolize the TOWNS,

4. whose number and identity are represented by escutcheons linked by a chain.

5. Each town surrenders its CROWN (throne)

6. and its KEYS to the King.

7. To the left, Mars, carrying a SHIELD WITH THE FLEUR-DE-LYS (the French army), tramples on

8. an URN representing the river on whose banks the enemy was conquered.

9. In the middle distance HERCULES, symbol of heroic valour, assisted by MINERVA, symbol of protection, attacks

10. a rock, to which clings the SPANISH LION, representing the fortress of BESANÇON.

11. This fortress is defended not only by a SOLDIER (military valour)

12. but by the harshness of the season, symbolized by a GRIZZLED OLD MAN (winter)

13. accompanied by the WINDS

14. and the signs of PISCES,

15. ARIES,

16. and TAURUS, representing the time that the conquest took place.

17. Above the King is VICTORY, symbolized by the laurel wreath,

18. GLORY, represented by the obelisk and the golden diadem,

19. RENOWN, represented by her trumpets,

20. and PEACE, holding olive branches and the horn of plenty.

21. To the right is the IMPERIAL EAGLE, troubled and menacing, but not intervening.

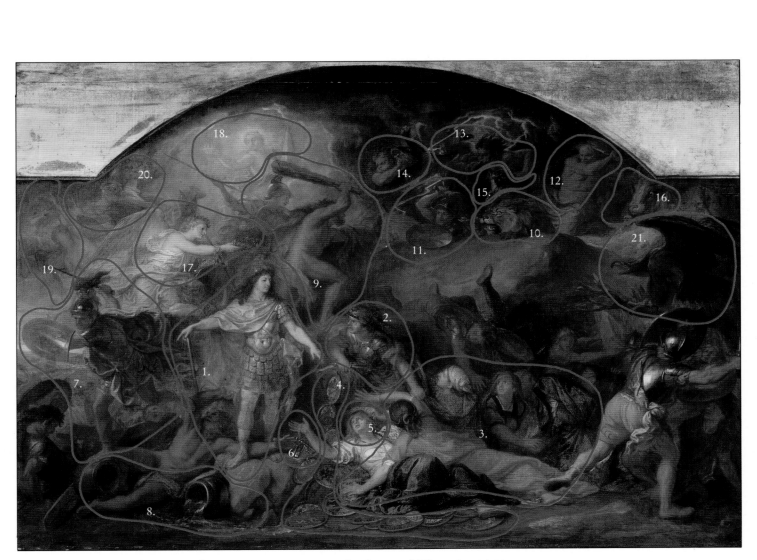

Charles LE BRUN, The Franche-Comté Conquered a Second Time in 1674, VERSAILLES.

The third step consisted in sketching the general idea of the composition on paper. He drew the main figures and elements of the decor in black chalk, respecting precise geometric forms in the composition. Most often he grouped masses either in pyramids or on the diagonal axis. Since he tended to divided scenes into separate groups, he would use a series of pyramids or diagonal lines, or a combination of the two. The majority of his scenes were set outdoors. He usually added a glimpse of clear sky in one corner of the canvas in order to lighten the composition. For the same reason he added a window or a door in the background of an indoor scene in order to always be able to expose some sky.

The same subject in different geometric compositions.

The Passage of the Granicus, (diagonal composition) X-4

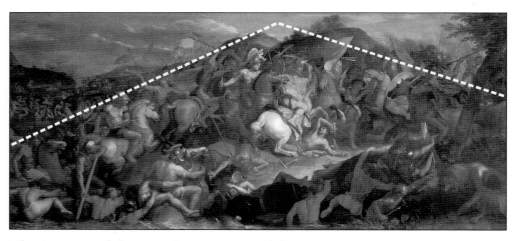

The Passage of the Granicus, (pyramidal composition) X-5

"He usuallly added a glimpse of clear sky in one corner of the canvas in order to lighten the composition."

Moses Defending the Daughters of Jethro

Theseus Abandons Ariadne at Naxos

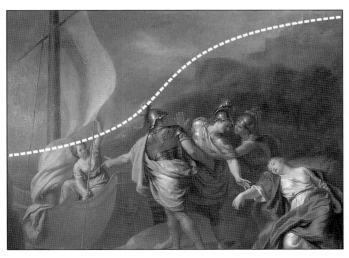

X-6

X-7

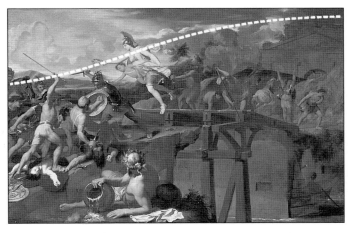

Horatius Cocles

X-8

Mucius Scaevola before Porsena

X-9

". . . For the same reason, he added a window or a door in the background of an indoor scene in order to always be able to expose some sky."

Grace, PARIS, LOUVRE

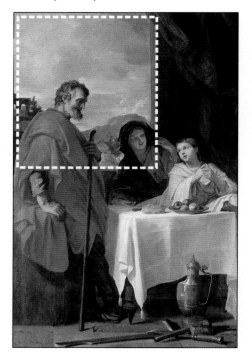

X-10

The Meal at the House of Simon

X-11

The Holy Family X-12

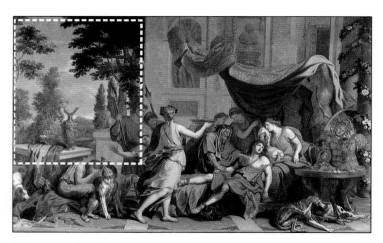

The Death of Meleager X-13

The Battle of Arbella, X-38

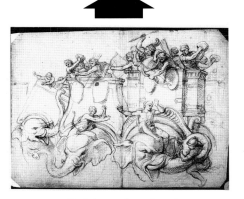

LOUVRE, Cabinet des dessins, X-37

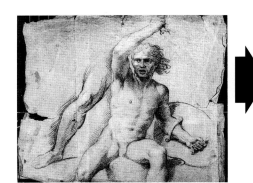

LOUVRE, Cabinet des dessins, X-39

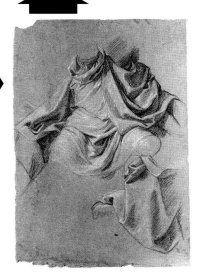

LOUVRE, Cabinet des dessins, X-40

The sixth step consisted in producing the painting from the finished sketches. Some elements could change in the course of the painting, but the work as a whole had already been planned down to the smallest details. This accounts for the speed with which LE BRUN executed his canvases. When a work was not entirely of his own creation, he concentrated on the main figures and usually left the backgrounds and the scenery to his assistants. Once their work was done, he added the finishing touches to the painting in order to give it greater unity.

Even if many of his canvases were produced with the collaboration of other painters, recognition from the community generally went to LE BRUN alone. One can now better appreciate the genius behind the works of this artist, for whom art had more meaning than impulsive brush-strokes on the canvas.

DRAWINGS

PHYSIONOMY OF HEADS

On March 28, 1671, before the ROYAL ACADEMY OF PAINTING AND SCULPTURE, LE BRUN, in the presence of COLBERT, delivered the lecture on physiognomy that he had previously given on March 7 of that same year, and probably also in 1668. He presented *"all of the various manifestations that he had drawn, both animal and human heads, pointing out the features marking their natural inclinations."* (Minutes of the Academy, I p. 358-359)

The complete text of the lecture has been lost. All that remains is a confusing synthesis by NIVELON, summaries by TESTELIN and PICART published after LE BRUN's death, and an essay by MOREL D'ARLEUX introducing a published volume of plates in 1806.

The goal of physiognomy is to judge character according to the features of the face. LE BRUN's reflections conform to research on the subject since ancient times; he was helped by the publication in 1655-1656 of the French translation of DELLA PORTA's work entitled *De Humana physiognomia.*

But LE BRUN was not satisfied with comparing the characteristics of the human face with those of animals in these remarkable drawings. Drawing on the work of DESCARTES (*Passions de l'âme*, 1649) which identified the pineal gland, located in the centre of the brain, as the seat of the soul, he studied the lines linking different points of the head in a complex geometry which revealed the faculties of the spirit or character. Thus, the angle formed by the axis of the eyes and the eyebrows could lead to various conclusions, depending upon whether or not this angle rose toward the forehead to join the soul or descended toward the nose and mouth, which were considered to be animal features.

In numerous profile drawings of animals, there appeared a system of lines forming a triangle which, according to LE BRUN could determine the animal's character:

"It can be demonstrated by a triangle, that an animal's expressions go from the nose to the ear, and on to the heart; from there a line comes up to complete the angle with that of the nose, and when this line crosses the eye and when the lower one crosses the mouth, it indicates that the animal is savage, ferocious and carnivorous . . ."

There are approximately 250 drawings in the LOUVRE associated with LE BRUN's lecture: antique busts, anatomical drawings of heads, animals heads, and human heads in relation to animal heads. In 1806 they were combined into two albums.

TWO RAM'S HEADS

Pen and black ink, over a black chalk sketch.
H. 0.175 x W. 0.307. Squared in black chalk.

History
From the workshop of LE BRUN. Entered the collections of
LOUIS XIV in 1690; paraph of J. PRIOULT (L. 2953); museum
stamp (L. 1886 a) Volume I, Folio 35.
Inventory 28077, Cabinet des dessins, LOUVRE.

Bibliography
MOREL D'ARLEUX, no. 10273 - JOUIN, 1889, p. 592 - GUIFFREY
and MARCEL, VIII no. 6644, repr. BALTRUSAITIS, 1983, p 28,
repr.

THREE PHYSIOGNOMIC HEADS INSPIRED BY THE
RAM

Pen and black ink, over a black chalk sketch, heightened with
grey wash, on beige paper. H. 0.214 x W. 0.327. Squared in
black chalk.

History
See above.
Inventory 28078, Cabinet des dessins, LOUVRE.

Bibliography
MOREL D'ARLEUX, no. 10273 - JOUIN, 1889, p. 592 - GUIFFREY
and MARCEL, VIII no. 6645, repr. - BALTRUSAITIS, 1983, p. 28,
repr.

The representation of man and animal
here is very close to the plate of the man-
sheep by G. B. DELLA PORTA. The same search
for similarities between man and animal
seen in preceding drawings is evident here
in the distortion of the man's features; how-
ever, since there is little exaggeration, the
human figures are only slightly caricatured.

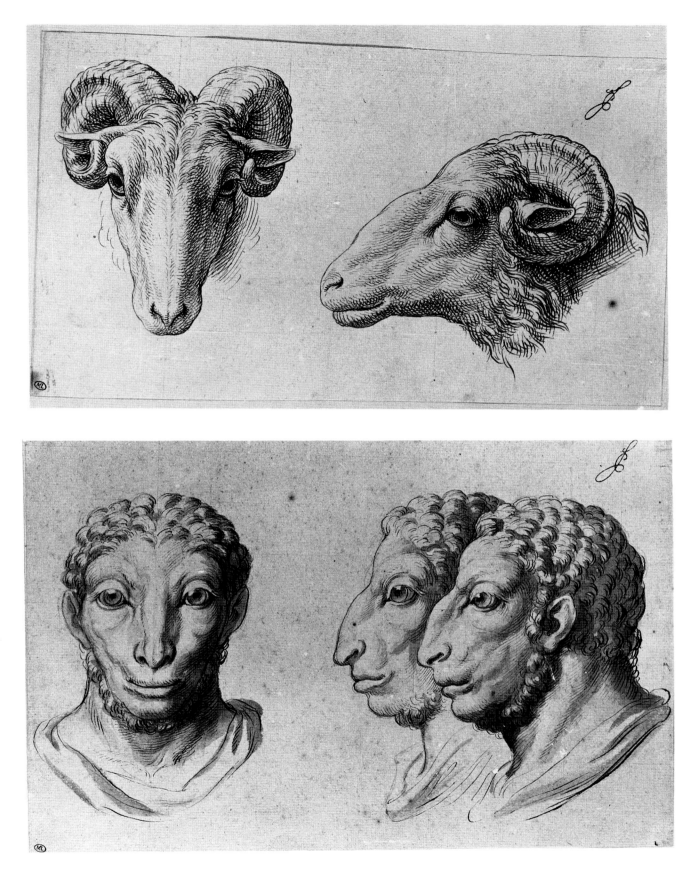

Paris, Louvre

TWO HEADS OF ASSES

Pen and black ink, over a black chalk sketch.
H. 0.197 x W. 0.326. Squared in black chalk.

History
From the workshop of LE BRUN. Entered the collections of
LOUIS XIV in 1690; paraph of J. PRIOULT (L. 2953); museum
stamp (L.1886 a) Volume I, folio 29).
Inventory 28052, Cabinet des dessins, LOUVRE.

Bibliography
MOREL D'ARLEUX, no. 10257 - JOUIN, 1889, p.592 - GUIFFREY
and MARCEL, VIII, no. 6631, repr.

FOUR PHYSIOGNOMIC HEADS INSPIRED BY THE
ASS

Pen and black ink, over a black chalk sketch, heightened with
grey wash, on beige paper. H. 0.221 x W. 0.328. Squared in
black chalk.

History
See above.
Inventory 28053, Cabinet des dessins, LOUVRE.

Bibliography
MOREL D'ARLEUX, no. 10257 - JOUIN, 1889, p. 592 - GUIFFREY
and MARCEL, VIII, no. 6632, repr.

As in other drawings, the animal is
seen from the front and in profile. The stu-
pidity of the ass, shown in the lines of the
eyes and brows, seems to have been trans-
posed into the expressions of the men, with
their exaggeratedly long ears.

The physiognomic geometry of the ass
is presented comprehensively in another
drawing (Inv. 28050). On the same sheet,
the word *"obstinacy"* appears in LE BRUN's
handwriting in two places where the signifi-
cant lines intersect: in the middle of the fore-
head and at the level of the upper eyelids.

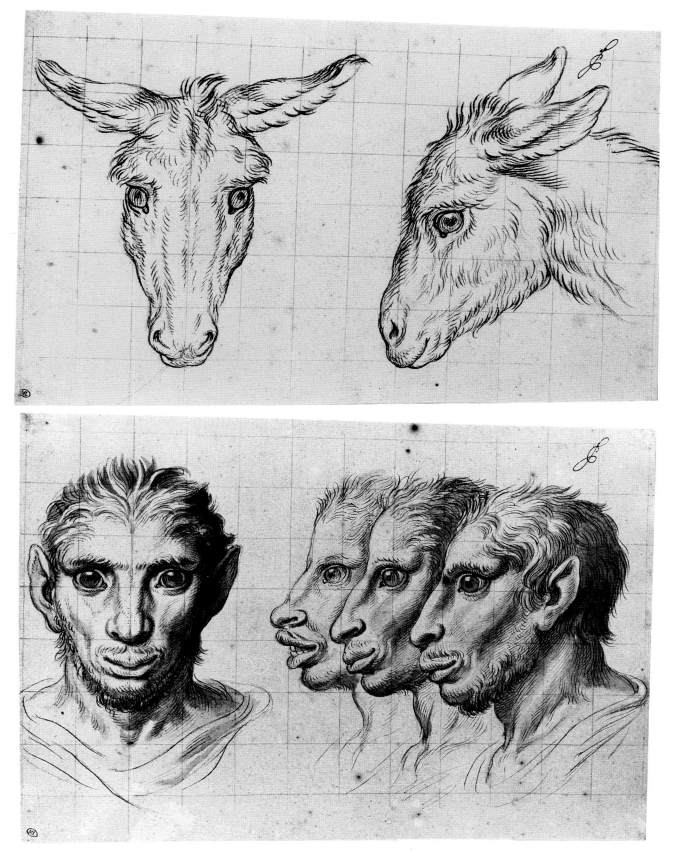

Paris, Louvre

THREE EAGLE'S HEADS

Pen and black ink, heightened with grey wash, on beige paper.
H. 0.218 x W. 0.316.

History
From the workshop of LE BRUN. Entered the collections of LOUIS XIV in 1690; paraph of J. PRIOULT (L. 2953); museum stamp (L. 1886 a) Volume I, Folio 24.
Inventory 28062, Cabinet des dessins, LOUVRE.

Bibliography
MOREL D'ARLEUX, no. 10264 - JOUIN, 1889, p. 592 - GUIFFREY and MARCEL, VIII no. 6625, repr. - BALTRUSAITIS, 1983, p. 29, repr.

THREE PHYSIOGNOMIC HEADS BASED ON THE EAGLE

Pen and black ink, heightened with grey wash, on beige paper.
H. 0.224 x W. 0.317.

History
See above.
Inventory no. 28063, Cabinet des dessins, LOUVRE.

Bibliography
MOREL D'ARLEUX, no. 10264 - JOUIN, 1889, p. 592 - GUIFFREY and MARCEL, VIII, no. 6626, repr. BALTRUSAITIS, 1983, p. 26, repr. p. 29.

This is the most elaborate technique used here. Three men, one seen from the front and two in profile, have characteristics found among birds of prey: *"a pointed and curved nose, a wide mouth, and huge brilliant eyes". "Since their forehead is not particularly high, they are not noble heroes."* (BALTRUSAITIS, 1983, p. 26)

The same figures of men and animals are presented on other sheets, in simplified drawings with horizontal lines maintaining the similarity between the heads seen from the front and those in profile. (Inv. 28060, 28061)

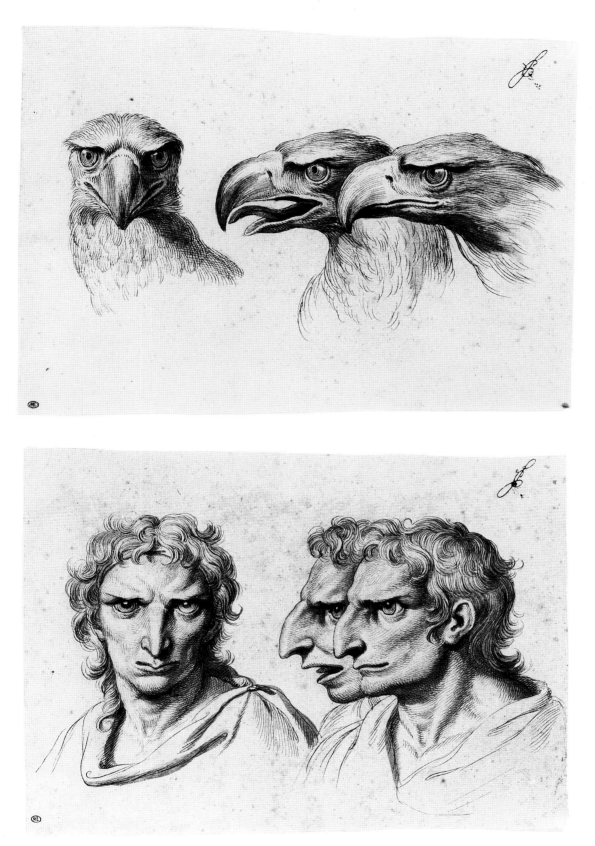

Paris, Louvre

TWO CAMEL'S HEADS

Pen and black ink heightened with grey wash.
H. 0.233 x W. 0.352. Squared in black chalk.

History
From the workshop of LE BRUN. Entered the collections of
LOUIS XIV in 1690; paraph of J. PRIOULT (L. 2953); museum
stamp (L. 1886 a) Volume I Folio 44.
Inventory 28091, Cabinet des dessins, LOUVRE.

Bibliography
MOREL D'ARLEUX, no. 10281 - JOUIN, 1889, p. 592 - GUIFFREY
and MARCEL, VIII, no. 6654, repr. - BALTRUSAITIS, 1983, p. 27,
repr.

Exhibitions
Paris, Orangerie, 1977-1978, no. 181, repr.
Paris, Louvre, 1985-1986, no. 91, repr.

THREE PHYSIOGNOMIC HEADS INSPIRED BY THE
CAMEL

Pen and black ink, over a black chalk sketch, heightened with
grey wash, on beige paper. H. 0.229 x W. 0.327. Squared in
black chalk.

History
See above.
Inventory 28092, Cabinet des dessins, LOUVRE.

Bibliography
MOREL D'ARLEUX, no. 10281 - JOUIN, 1889, p. 592 - GUIFFREY
and MARCEL, VIII, no. 6655, repr. - BALTRUSAITIS, 1983, p. 27,
repr.

Exhibitions
Paris, Orangerie, 1977-1978, no. 182, repr.
Paris, Louvre, 1985-1986, no. 92, repr.

The animal and human faces are drawn
with pen and black ink, and heightened
with grey wash to accentuate the contours.
The animals are given a natural treatment; it
should be borne in mind that camels were
among the attractions in the menagerie at
VERSAILLES. According to LE BRUN's argu-
ment, the geometry of the profile is indica-
tive of intelligence in camels as well as in
elephants and monkeys.

The system of triangulation described
in LE BRUN's lecture (Inv. 28029 and 28090)
appears in other drawings comparing
camels and humans.

Paris, Louvre

TWO CAT'S HEADS

Pen and black ink, over a black chalk sketch.
H. 0.146 x W. 0.289. Squared in black chalk.

History
From the workshop of LE BRUN. Entered the collections of
LOUIS XIV in 1690; paraph of J. PRIOULT (L. 2953); museum
stamp (L. 1886 a). Volume I, Folio 49.
Inventory 28099, Cabinet des dessins, LOUVRE.

Bibliography
MOREL D'ARLEUX, no. 10286 - JOUIN, 1889, p. 592 - GUIFFREY
and MARCEL, VIII no. 6662, repr.

FOUR PHYSIOGNOMIC HEADS BASED ON THE
CAT

Pen and black ink, over a black chalk sketch, heightened with
grey wash, on beige paper. H. 0.236 x W. 0.319. Squared in
black chalk.

History
See above.
Inventory 28100, Cabinet des dessins, LOUVRE.

Bibliography
MOREL D'ARLEUX, no. 10286 - JOUIN, 1889, p. 592 - GUIFFREY
and MARCEL, VIII no. 6663, repr.

In the majority of comparative draw-
ings, LE BRUN tended to humanize the ani-
mals and dehumanize the people; here,
however, the human features are barely dis-
torted, since the association between man
and cat is rooted in popular tradition. In
other drawings of cats, LE BRUN had written
in the dominant characteristics: *"stubborn,
mistrustful; stubborn, timorous; or stubborn
and timid."*

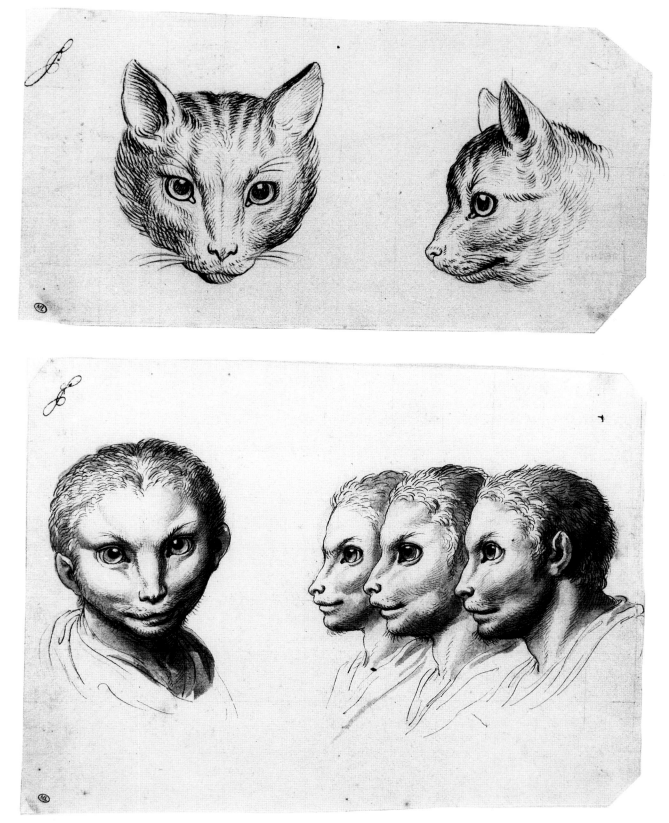

Paris, Louvre

EXPRESSION OF THE PASSIONS: TERROR

Pen and black ink, over a black chalk sketch.
H. 0.195 x W. 0.255.
Framed with a line in pen and black ink, inscribed in pen and
black ink at the top: *G La Frayeur* and printed capital letter
G.; at bottom: *no. 32.*

History
From the workshop of LE BRUN. Entered collections of
LOUIS XIV in 1690; paraph of J. PRIOULT (L. 2953); museum
stamp (L. 1886 a).
Inventory 28296, Cabinet des dessins, LOUVRE.

Bibliography
MOREL D'ARLEUX, no. 10441 - JOUIN, 1889, p. 589 - GUIFFREY
and MARCEL, VIII no. 6496, repr.

Exhibitions
Versailles, 1963, no. 132, repr.

To illustrate his lecture on the expres-
sion of the passions presented in 1668 at the
ROYAL ACADEMY OF PAINTING AND SCULPTURE,
LE BRUN had had prepared pen and ink stud-
ies schematizing the different emotions.
There were 24 diagrams in all, each one
consisting of two front views and one pro-
file, showing the distortion of facial fea-
tures under the influence of the passions
(horizontal lines marked by asterisks) com-
pared to the face at rest (unmarked dotted
lines). One of these is presented here.

In his lecture, LE BRUN gave a lengthy
description of the external signs of terror.
*"A person affected by extreme terror
will have eyebrows drawn up in the
middle; the muscles controlling their
movements will become very promi-
nent, swollen and pressed against
each other, descending towards the
nose; the nose, as well as the nostrils,
will appear drawn up. The eyes will
appear fully open, the upper eyelid
will be hidden beneath the brow . . .
the mouth will be wide open, the cor-
ners will be drawn back."*

(*Traité des passions*, published in 1698, reproduced in JOUIN,
p. 381 and 382)

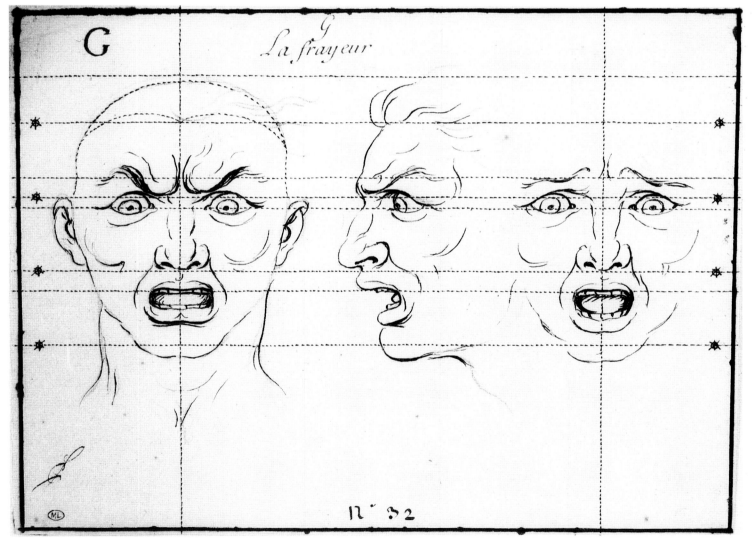

Paris, Louvre

EYE MOVEMENTS

Black chalk, H. 0.358 x W. 0.243. Inscribed in pen and black and brown ink in capital letters: A and E (twice).

History
From the workshop of LE BRUN. Entered the collections of LOUIS XIV in 1690; paraph of J. PRIOULT (L. 2953); museum stamp (L. 1886 a). Volume II, Folio 70.
Inventory 28226, Cabinet des dessins, LOUVRE.

Bibliography
MOREL D'ARLEUX, no. 10370 - JOUIN, 1889, p. 593 - GUIFFREY and MARCEL, VIII, no. 6759.

Exhibition
Versailles, 1963, no. 137, repr.

Several sheets of eyes, seen from the front and in profile are included in the second album. They relate to the two lectures on the expression of the passions and on physiognomy delivered by LE BRUN at the ROYAL ACADEMY OF PAINTING AND SCULPTURE.

This sheet contains men's eyes arranged in five rows; on other sheets there are various *"aspects and movements of the eyes"* of animals.

LE BRUN maintained that *"the eyebrow is the one feature of the face where the passions can best be observed."* To reinforce his conviction, he added that *"it is true that the pupil of the eye, with its fire and its movement, clearly shows us the agitation of the soul, but it does not reveal the nature of this agitation."* (*Traité sur l'expression des passions,* published by JOUIN, p. 377)

One can recognize, by referring exclusively to the movements of the eyebrows, from top to bottom, expressions of anger, expectation, esteem, fear and horror, schematically studied in other drawings.

On this single sheet of studies, LE BRUN, using only black chalk, was able to give these expressions a striking, even unsettling quality.

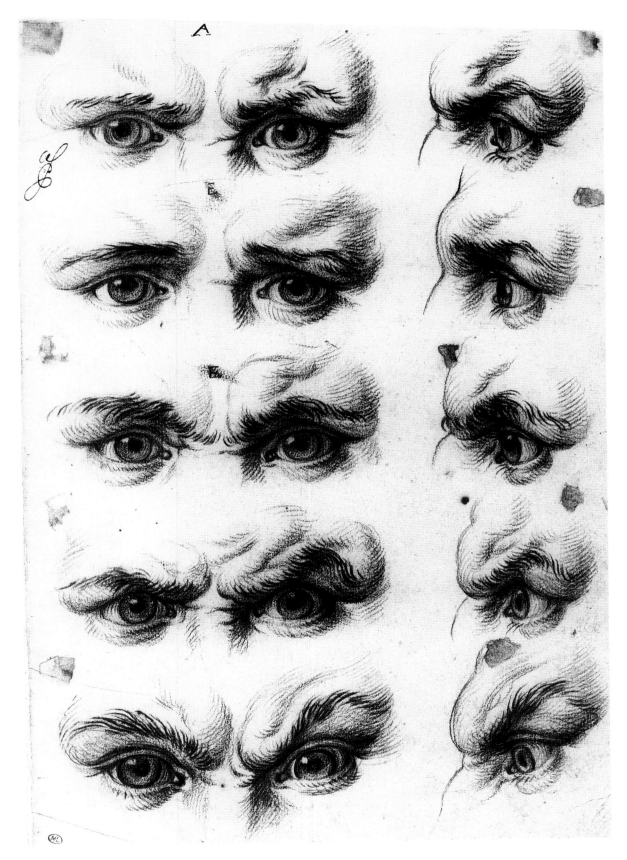

Paris, Louvre

Pen and black ink, over a black chalk sketch, heightened with watercolour, with some lines in red chalk, on three vertically joined sheets. H. 0.235 x W. 0.390.

History
From the workshop of LE BRUN. Entered the collections of LOUIS XIV in 1690; paraph of J. PRIOULT (L. 2953); Museum stamp (L. 1886).
Inventory 28236, Cabinet des dessins, LOUVRE.

Bibliography
MOREL D'ARLEUX, no. 10380 - JOUIN, 1889, p. 591 - GUIFFREY and MARCEL, VIII, no. 6564 - PINAULT, 1984, s/le no. 68 -

This drawing was inserted into the collection of studies used to illustrate the lecture on physiognomy (Vol. II, Folio 74). It consists of three diagrams representing the brain, cerebellum and the network of cranial nerves, shown in watercolour.

In these illustrations, LE BRUN was directly inspired by the work of ANDRÉ VESALE (*De humani corporis fabrica*) published in 1542. Written for physicians and artists, this work remained the bible of artistic anatomy until the beginning of the nineteenth century (HUARD, 1980).

The skull, viewed from above (centre) is an exact copy of Plate No. 48 of the 4th book in the *Fabrica*. The heads, seen from the front and in profile are treated on two other sheets (Inv. 28237 and . 28238) and are copied here in miniature to complete the central diagram. The profile comes from the upper half of Plate 49 of the *Fabrica*; the front view is a transposition.

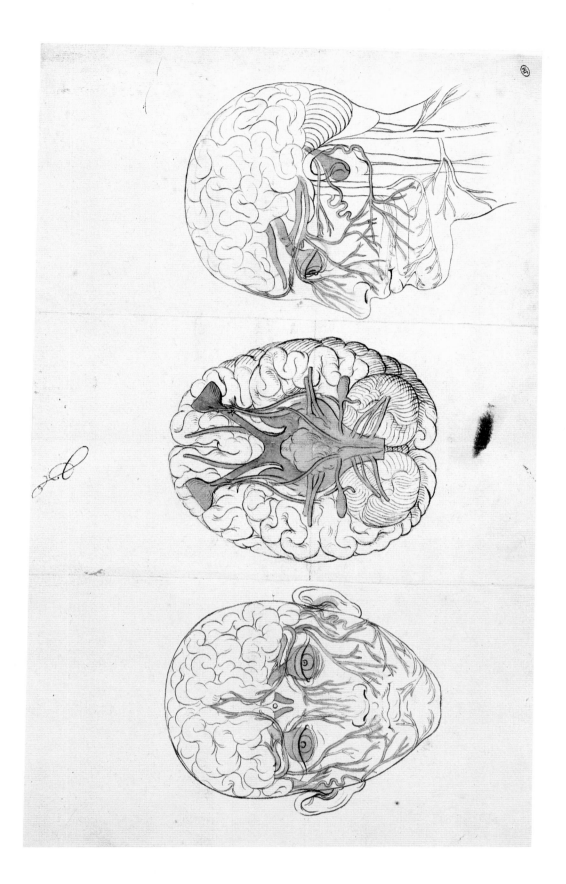

EAGLE WITH OUTSPREAD WINGS

Black chalk, heightened with white, on beige paper. Separate small rough sketch in red chalk. H. 0.242 x W. 0.409. Completely glued to backing.

History
From the workshop of LE BRUN. Entered the collections of LOUIS XIV in 1690; paraphs of A. COYPEL (L. 478) and R. DE COTTE (L. 1963); stamp of the Museum Commission (L. 1899) and the first curator (L. 2207a)
Inventory 27.935, Cabinet des dessins, LOUVRE.

Bibliography
MOREL D'ARLEUX, no. 10146 - JOUIN, 1889, p. 628 - GUIFFREY et MARCEL, VIII, no. 7878 - BACOU, 1974, s/le no.36 l- MONTAGU, 1986, p. 236, note 6 - STARCKY, 1988, s/le no. 147.

Exhibitions
Paris, Louvre, 1985/1986, no. 62, repr.

JENNIFER MONTAGU suggests that a connection must be made between this study of an eagle and the *Battle of Arbella,* where an eagle appears at a crucial point in the battle, as recounted by QUINTUS-CURTIUS (book IX):
 " . . . whether it was illusion or reality, those around Alexander swear to have seen an eagle hovering above his head;. neither the fracas of weapons nor the groans of the dying seemed to frighten it. It appeared to be not in flight, but rather suspended in the air. The soothsayer Aristander, dressed in his white robes and bearing a laurel branch, pointed out the bird to the soldiers in the throes of battle as a certain omen of their victory . . ."
The drawing's free and vigorous style suggests that it was drawn from life. The menagerie at VERSAILLES, designed by LE VAU, was completed in 1664 and gave artists the opportunity to conduct field studies. LE BRUN made use of it, notably for his studies of elephants.

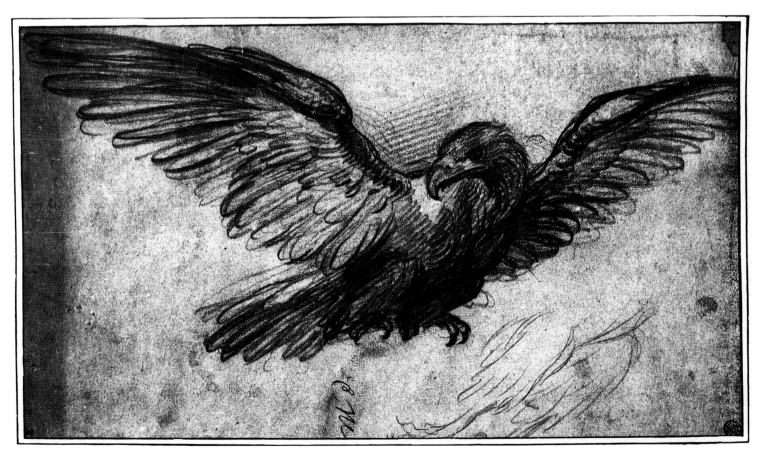

Paris, Louvre

HALF-LENGTH DRAWING OF NUDE WOMAN

Red chalk, heightened with white, on beige paper, double thickness. Irregularly cut along contours. H. 0.152 x W. .0197.

History
J. MASSON (L. 1494 a) - ÉCOLE DES BEAUX-ARTS (L. 829 a).
MASSON inventory 1024.

Bibliography
Wilhelm, 1963, p. 18, repr.

Exhibitions
Paris, École des Beaux-Arts, 1961, no. 54 - Versailles, 1963 - no. 79, repr.

In about 1653, LE BRUN painted a large allegorical composition evoking Sunrise on the ceiling of the Great Study in the HOTEL DE LA RIVIERE, located today at the MUSÉE CARNAVALET. In the centre, APOLLO, seated in his chariot, is accompanied and attended by the Hours.

The drawing is a study for one of the Hours, who is washing APOLLO's feet. The element of fullness is characteristic of the young LE BRUN and shows the influence of his master, VOUET.

Paris, Ecole Nationale Supérieure des Beaux-Arts

DRAPED WOMAN, SEATED

Red chalk, heightened with white, on beige paper.
H. 0.377 x W. 0.278.
Completely glued to backing.

History
From the workshop of LE BRUN. Entered the collections of
LOUIS XIV in 1690; paraphs of A. COYPEL (L. 478) and
R. DE COTTE (L. 1963); stamp of the Museum Commission (L.
1899) and the first curator (L. 2207a).
Inventory 27964, Cabinet des dessins, LOUVRE.

Bibliography
MOREL D'ARLEUX, no. 10173 - JOUIN 1889, P. 627 - GUIFFREY
and MARCEL, VIII no. 7406 - MONTAGU, 1963, p. 407.

Exhibitions
Versailles, 1963, no. 91, repr.

Between 1658 and 1660, LE BRUN decorated the Hall of the Muses at VAUX-LE-VICOMTE. On the octagonal ceiling, the artist represented Fidelity being carried off to heaven. Where the walls meet the ceiling, eight Muses seated in pairs are depicted with their attributes; the ninth, CLIO, Muse of History and Epic Poetry, is included in the ceiling scene with Prudence, Virtue and Reason, allegorical figures evoking qualities attributed to the master of the house.

The drawing presented here is a study for POLYMNIA, a muse associated with several disciplines, in whom LE BRUN wished perhaps to personify painting. The linear contours and the loose hatching that gives volume and accentuates features are typical of the artist's graphic style before 1660. As in all of LE BRUN's studies, the right hand is cut off by the edge of the paper and is rendered separately.

Paris, Louvre

NUDE WARRIOR IN HELMET, BOWING DOWN

Red chalk, heightened with white, on beige-grey paper.
H. 0.453 x W. 0.296.

History
From the workshop of LE BRUN. Entered the collections of
LOUIS XIV in 1690; paraph of J. PRIOULT (L. 2953), A. COYPEL
(L. 478) and R. DE COTTE (L. 1963); museum stamp (L. 1886).
Inventory 28978, Cabinet des dessins, LOUVRE.

Bibliography
MOREL D'ARLEUX, no. 10.504/106 - JOUIN, 1889, p. 625 -
GUIFFREY and MARCEL, VIII, no. 6865, repr.

Exhibition
Paris, Louvre, 1985-1986, no. 50, repr.

LE BRUN painted the vault of the Great Hall of VERSAILLES (known today as the HALL OF MIRRORS) between 1680 to 1684. The subject, intended to glorify the King, represents great deeds from the first eighteen years of LOUIS XIV's personal reign. The vault is divided into seven large compartments illustrating military actions, completed by six octagonal monochromes and eighteen oval medallions recalling the King's diplomatic successes, great undertakings and benevolent acts.

One of these large compartments, entitled *The King Arms Himself on Land and Sea*, is an allegorical representation of the preparations for the war against HOLLAND. The King, dressed as an ancient warrior but wearing the heavy wig of the period, is standing and giving orders to all sides. He is surrounded by mythological or symbolic figures playing the roles imparted to them: APOLLO, MINERVA, NEPTUNE, VULCAN, MARS, MERCURY, CERES, FORESIGHT and VIGILANCE.

The drawing is a study for one of the officers led by MARS, god of War; he is represented nude save for a helmet; he bows down in a respectful tribute. The cloak in which he will be draped is the object of another study (Inv. 29.044). The style, with its confident, continuous lines and relief rendered by fine hatching and stumping, is characteristic of the drawings LE BRUN executed for the Great Hall.

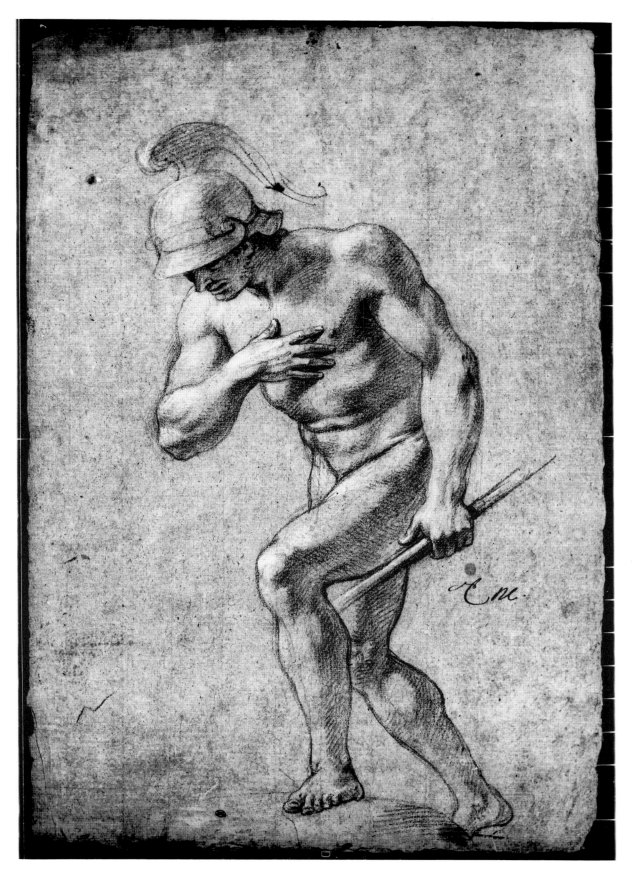

Paris, Louvre

HEAD OF ALEXANDER

Pastel on beige paper. H. 0.409 x W. 0.274. Completely glued to backing.

History
Acquired in 1828 by the family of the architect FONTAINE.
Inventory 29878, Cabinet des dessins, LOUVRE.

Bibliography
MOREL D'ARLEUX, no. 27711 - REISET, 1869, no. 844 - JOUIN,
1889, p. 498 - GUIFFREY and MARCEL, VIII no. 6257 -
THUILLIER, 1963, p.405 - MONNIER, 1972 - 2, no. 7, repr.

This is the head of ALEXANDER as it appears in the painting entitled *The Queens of Persia*. Details of the helmet, the arrangement of the locks of hair and even the angle of the head are exactly as they occur in this pastel. We might well wonder, as did MONNIER (1972, no.7) if this is not one of the *"eighteen heads for The Battles of Alexander executed in pastel by Verdier"* cited in the inventory done after the death of SIR FRANÇOIS BENOIST MASSON, sculptor to the King . . . December 29, 1728 (published by D. WILDENSTEIN, 1967, p. 86).

LE BRUN was very concerned with historical accuracy. ABBÉ DUBOS (*Reflexions critiques sur la poésie et la peinture*, v. 1, Paris, 1719) reports that when painting of *The Queens of Persia*, *"for the head of Alexander, Monsieur LeBrun was given a medal with the head of Minerva, on the back of which was inscribed the name of Alexander. Contrary to what was generally held to be true at the time, in this painting the prince appears as beautiful as a woman. As soon as he was made aware the error, LeBrun in fact corrected it and he gave us the true head of Alexander in the paintings of The Passage of the Granicus and Alexander's Entry into Babylon.*

He took his inspiration from a bust of the prince which was displayed in one of the bosquets at Versailles . . . and which had been brought from Alexandria."

110

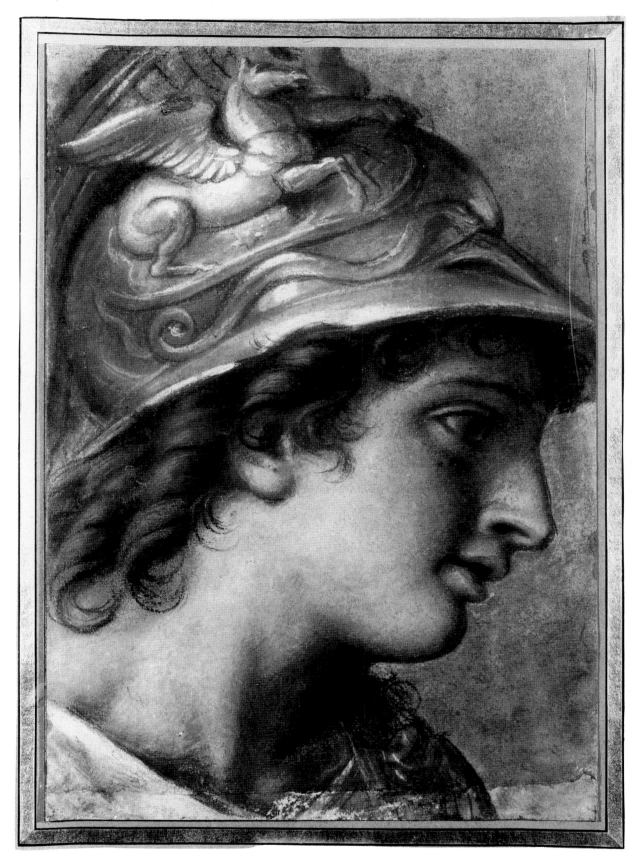

Paris, Louvre

ALEXANDER AND CENUS

Black chalk. H. 0.198 x W. 0.353. Inscribed in black chalk in the artist's handwriting: left: *Alexander*; centre: *Cenus*.

History
From the workshop of LE BRUN. Entered the collections of LOUIS XIV in 1690; paraphs of J. PRIOULT (L. 2953), A. COYPEL (L. 478) and R. DE COTTE (L. 1963); Museum stamp (L. 1886) Inventory 29531, Cabinet des dessins, LOUVRE.

Bibliography
MOREL D'ARLEUX, no.10518/B - JOUIN, 1889, p. 498 - GUIFFREY and MARCEL, VIII, no. 6261, repr.

Exhibitions
Paris, the Gobelins, 1962, no.59.

BOTH JOUIN and GUIFFREY and MARCEL erroneously link this drawing to the painting of the *Queens of Persia*. The drawing, which was never produced as a painting, in fact illustrates another episode in the history of ALEXANDER. However, NIVELON, in his lengthy descriptions of LE BRUN's proposed or realized works relating to ALEXANDER, makes no mention of it.

The scene is easily identifiable; first, the artist wrote in the names of the two main figures, ALEXANDER on the left and CENUS on the right; second, it matches the account given of it by QUINTUS-CURTIUS (Book IX). Following the conquest of INDIA, ALEXANDER, standing on a platform, delivered a lengthy speech to rekindle the courage of his battle-weary soldiers.

"Caenus was bold enough to approach the platform, indicating that he wished to speak; when the soldiers saw him remove his helmet—it was the custom to do so when addressing the King—they begged him to plead on behalf of the army. So he began: '. . . we have crossed land and sea, we know countries better than their inhabitants do . . . Look at these haggard faces, these bodies hideous with sores, *covered in scars; our spears are blunt, our weapons and our clothes are worn out."*
(QUINTUS-CURTIUS. *De la vie et des actions d'Alexandre le Grand,* translated by M. DE VAUGELAS, PARIS, 1653)

Paris, Louvre

DEATH OF THE WIFE OF DARIUS

Red chalk, heightened with white, on beige paper; red chalk
sketch on reverse side. H. 0.305 x W. 0.520.

History
From the workshop of LE BRUN. Entered the collections of
LOUIS XIV in 1690; paraphs of J. PRIOULT (L. 2953), A. COYPEL
(L. 478) and R. DE COTTE (L. 1963).
Inventory 29530, Cabinet des dessins, LOUVRE.

Bibliography
MOREL D'ARLEUX, no. 10518/A - JOUIN, 1889, p. 622 -
GUIFFREY and MARCEL, VIII no. 6364, repr.

Exhibition
Versailles, 1963, no. 117, repr.

This was another unrealized project for *History of Alexander* series. As noted by JENNIFER MONTAGU (1963, s/le no. 117) the style of this drawing is similar to that of *Alexander's Entry into Babylon.* LE BRUN thus seems to have given thought to this subject relatively early, between 1660 and 1665, that is, at the time when he was preoccupied with representing the character and virtuous acts of ALEXANDER.

As in the other compositions, LE BRUN was relatively faithful to QUINTUS-CURTIUS' account (Book IV): *"the princess, overcome by troubles . . . fainted into the arms of her daughters and of her mother-in-law the Queen and soon afterwards breathed her last breath. . . . [Alexander] went to the tent where Sisygambis was sitting by the body. Upon seeing the revered princess lying there on the ground, his grief intensified. Her daughters were around her . . . she saw her young son before her eyes . . . it was as if Alexander were weeping among his own kin, and was there more to console himself than to console the others."*

On the reverse side of this same page, there is a rapid sketch of a variation on the group of the wife of Darius.

There is a slightly different version of the scene in the NATIONAL MUSEUM IN STOCKHOLM (NM 2714/1863). Several isolated figure studies relating to either of the two versions are conserved at the LOUVRE.

Paris, Louvre

ALEXANDER'S TRAVELS IN JUDEA

Black chalk, on beige paper. H. 0.267 x W. 0.426.

History
From the workshop of LE BRUN. Entered the collections of
LOUIS XIV in 1690; paraphs of J. PRIOULT (L. 2953), A. COYPEL
(L. 478) and R. DE COTTE (L. 1963)
Inventory 29498, Cabinet des dessins, LOUVRE.

Bibliography
MOREL D'ARLEUX, no. 10516/32 - JOUIN, 1889, p. 622
GUIFFREY and MARCEL, VIII, no. 6363.

This is an unrealized plan for another
episode of the *History of Alexander.*
Nivelon gives the following description
of the scene represented by LE BRUN:

> *"Alexander, who was at the siege of
> the city of Tyre, made a trip to
> Judea; the great priest Jadus came
> before him, followed by all the
> Levites . . . (Alexander) bowed down
> before him out of the reverence he
> had for the great name of God writ-
> ten on the band of gold placed on
> the forehead of this great priest . . .
> this token of veneration was fol-
> lowed by other acts. Alexander
> made sacrifices in the temple of
> Jerusalem where Jadus revealed to
> him in the sacred books his future
> good fortune and the possession of
> the throne of the Persians."*

The drawing outlines the main lines of
the composition, with the city of TYRE in the
background at the left. LE BRUN does not
seem to have pursued this project any fur-
ther. Its style is similar to that of the first
studies done for the *Death of Darius.*

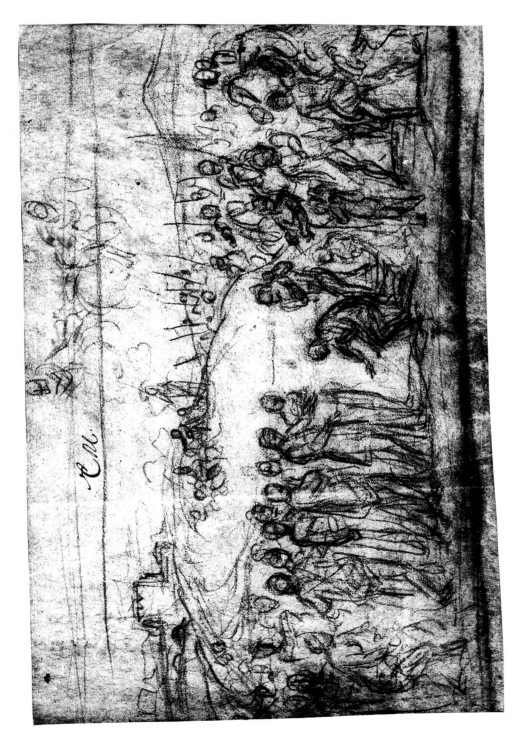

Paris, Louvre

THE BATTLE OF PORUS

Black chalk, on four sheets of grey-blue paper, vertically joined; the drawing as a whole is badly damaged. H. 0.528 x W. 1.455. Outlines have been incised with stylus. Reinforced from behind.

History
From the workshop of LE BRUN. Entered the collections of LOUIS XIV in 1690; paraphs of J. PRIOULT (L. 2953), A. COYPEL (L. 478) and R. DE COTTE (L. 1963).
Inventory 29424, Cabinet des dessins, LOUVRE.

Bibliography
MOREL D'ARLEUX, no. 10511 - JOUIN, 1889, p. 502 - GUIFFREY and MARCEL, VIII no. 6255.

NIVELON (p.180) is the best source of information on this unrealized work by LE BRUN, the last in the series, *The History of Alexander*. *"Monsieur LeBrun's final projects and his death deprived the King of the fourth large-scale painting which is the Battle of Porus. All that remained was a sketch of the figures, unclothed and unarmed, a practice which he* (LE BRUN) *had in order to achieve more accuracy and precision."*

This painted sketch, along with a drawing done by LE BRUN himself, listed in the inventory done after his death (JOUIN, p. 726), are no longer at the LOUVRE and seem to have disappeared. NIVELON maintains that it is from this drawing that VERDIER painted two smaller paintings.

Numerous plates, based on LE BRUN, were engraved on this subject. The figures in these plates are clothed, which poses the problem of models for costumes not drawn by LE BRUN. The most accomplished engraving is that of JEAN AUDRAN.

The drawing presented here is a copy traced from LE BRUN's original drawing. Judging by the engraving, it was probably done by NIVELON, for the contours have been gone over with a stylus. What makes this copy, with its nude figures, interesting, is that the left part was touched up by

LE BRUN. In the background, there is a reworking of ALEXANDER, surrounded by TAXILES and other officers of his army, preparing to *"remount a horse, his own having fallen dead"*. Similarly, LE BRUN had envisioned another version of the scene on this copy: reinforcements arriving on horseback can be seen through the trees, while in AUDRAN's engraving, there is an elephant carrying a howdah filled with warriors in that same place.

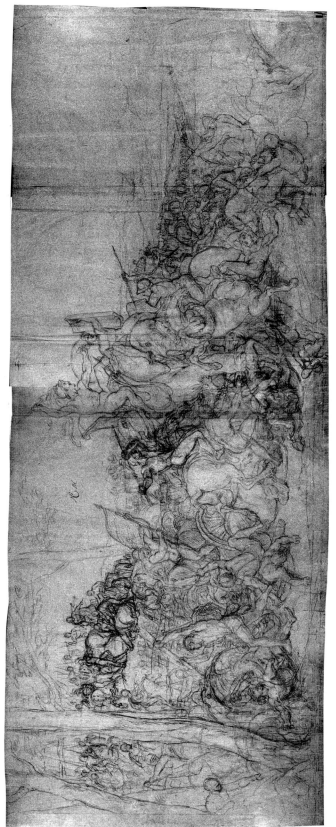
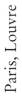

Paris, Louvre

Pen and black ink, heightened with grey wash, over a red and black chalk sketch. H. 0.285 x W. 0.472. Completely glued to backing.

History
From the workshop of LE BRUN. Entered the collections of LOUIS XIV in 1690; paraphs of A. COYPEL (L. 478) and R. DE COTTE (L. 1963).
Inventory 29621, Cabinet des dessins, LOUVRE.

Bibliography
MOREL D'ARLEUX, no. 10547 - JOUIN, 1889, p. 499 - GUIFFREY and MARCEL, VIII, no. 6244, repr.

Exhibitions
MAISONS-LAFFITTE, 1931, no. 9; Paris, LES GOBELINS, 1962, no. 68; VERSAILLES, 1963, no. 111, repr.

Though these are preliminary ideas, they already show a very well-developed conception of the painting as a whole. From the outset LE BRUN had settled on a diagonal composition (bottom left to top right) but he had not yet clearly depicted ALEXANDER among the pairs of horsemen in single combat. As seen in other group studies for the same painting (Louvre, Inv. 29.427, 29.429, 29.430) the boat-load of warriors preparing to land in the foreground to the right was soon abandoned, in order to disencumber this area of the painting.

LE BRUN did not make frequent use of pen and ink but it can be seen in his studies for complex compositions, since it allowed him to give a certain density to various figures sketched in red or black chalk. Moreover, in this drawing the highlights in grey wash are meant to establish, along with the white spaces, masses of light and shadow.

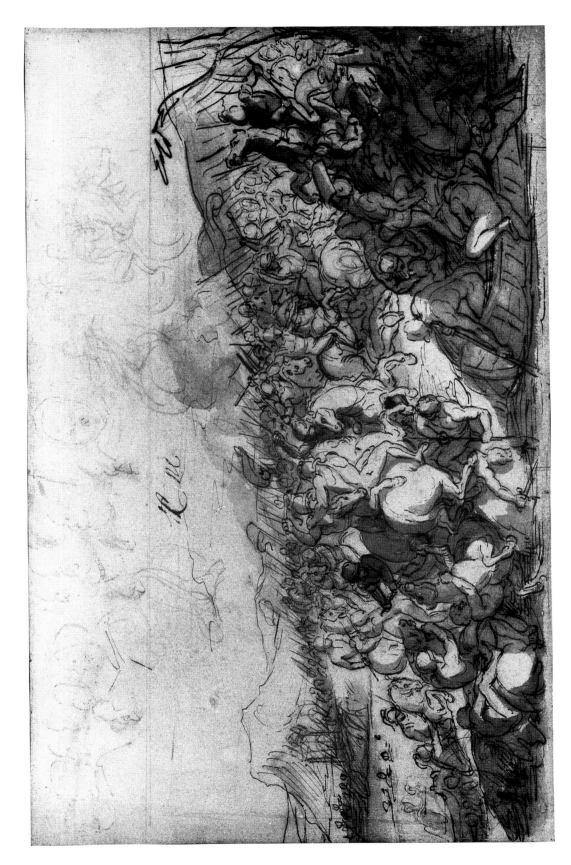

Paris, Louvre

THE DEATH OF DARIUS

Black chalk, heightened with white and brown pencil, grey and brown wash, on three pieces of beige paper joined vertically. H. 0.353 x W. 0.954. Completely glued to backing.

History
From the workshop of LE BRUN. Entered the collections of LOUIS XIV in 1690; paraphs of A. COYPEL (L. 478) and R. DE COTTE (L. 1963).
Inventory 27657, Cabinet des dessins, LOUVRE.

Bibliography
MOREL D'ARLEUX, no. 6649 - JOUIN, 1889, p. 572 - GUIFFREY and MARCEL, VIII no. 6262 repr. - POSNER, 1959, p. 243, fig. 8.

Exhibition
Versailles, 1963, no. 129, repr.

This large-scale drawing corresponds to the last version of the huge painting that LE BRUN intended to paint in the *History of Alexander* series. As seen in the three studies for the central portion of the same project, LE BRUN hesitated over the precise moment that he wished to illustrate. In a preliminary study (Inv. 29533), DARIUS, reclining in a horse-drawn chariot still in motion, is attacked by traitors from his camp intent on holding him prisoner. In another study, (Inv. 29532) he had decided to include the presence of ALEXANDER, led by the Macedonian POLISTRATUS (the same one who had discovered DARIUS and had heard his last words) but the scene is not yet in its final version; the horses are standing and DARIUS, lying in the chariot, is not in a conspicuous position. The third study (Inv. 29534) is closest to the final version; the horses have been slaughtered and ALEXANDER, recognizable by his plumed helmet, is getting ready to cover DARIUS with his cloak, which conforms to the written accounts of the life of ALEXANDER.

The drawing depicted here shows the completed project which was to be on the same scale as *The Battles*. The landscape is highly developed and numerous figures surround and balance the central scene, while in the background the detachment of ALEXANDER's army that had pursued DARIUS is arriving on the scene. LE BRUN excels here at depicting the dead and wounded horses, for which he had done several separate studies, particularly for the dead horse in the foreground to the right, with its pathetic, almost human gaze (Inv. 29567).

Though it was well underway, this project was never actually realized. As JENNIFER MONTAGU suggests (VERSAILLES exhibition, 1963), it dates from between 1667 and 1669, that is, between the completion of the *Battle of Arbella* and the beginning of the great painting of *Alexander and Porus*.

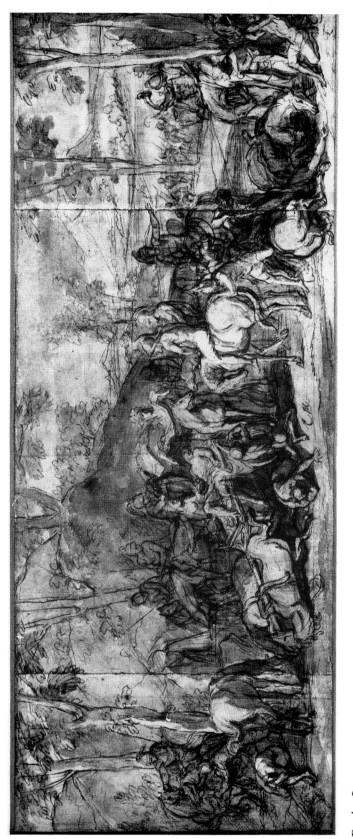

Paris, Louvre

CAPTURE OF THE CITY AND CITADEL OF GHENT
IN SIX DAYS - 1678

Red and black chalk, with red wash, on two sheets of beige paper joined vertically. H. 0.540 x W. 0.717. Squared in black chalk.
Outlines incised with stylus in upper half. Three sheets cut out and added to scenery in lower half. Inscribed in pen and brown ink, lower left: *six feet, three inches between trophies.*

History
From the workshop of LE BRUN. Entered the collections of LOUIS XIV in 1690; paraph of J. PRIOULT (L. 2952, noted twice); museum stamp (L. 1886)
Inventory 30067/MV 7310, Cabinet des dessins, LOUVRE.

Bibliography
MOREL D'ARLEUX, no. 6632 - GUIFFREY and MARCEL, VIII, no. 8489

This large drawing is a copy of the painting done on the vault of the Great Hall at VERSAILLES. The following description is found in the inventory done after LE BRUN's death: *"The lines of the entire painting of the Capture of Ghent, drawn partly in blacks and partly in red chalk, by Nivelon, to serve as a tracing."* In effect, that which corresponds to the painting proper is etched, probably with a view to subsequent engraving.

This very faithful copy gives an idea of the extraordinary opulence of the decoration of the Great Hall. The painting, rounded along the bottom, is part of a large compartment occupying the entire width of the vault. It is complemented by another painting directly across from it, entitled *The Spanish Thwarted during the Capture of Ghent.* Around the outside, NIVELON reproduced the frame, the setting of satyrs, victories, cupids, and below and to either side of the cartouche, the designs in gilded stucco.

The painting itself is an allegorical account of *"the capture of Ghent, which forced enemies to make peace."* The text that accompanies the engraved plates includes the following description:

"The King, carried by an eagle ... holds a thunderbolt in one hand and the formidable Ægis in the other. Vigilance and Secrecy walk by his side, and Glory hovers above him. He is pursued by Terror, represented by a winged woman wearing a headdress in the form of a lion's head. Below, the city of Ypres appears to be stricken by fear. In front of the King, Flanders, represented by the figure of a distressed woman, lifts up her mantle in surprise... near her is the city of Ghent in tears... she holds keys which Minerva snatches from her with one hand... Along the bottom of the painting ... the city of Valenciennes lies slain on the shield bearing its arms ... Mars pursues Discord, Envy and Fury."

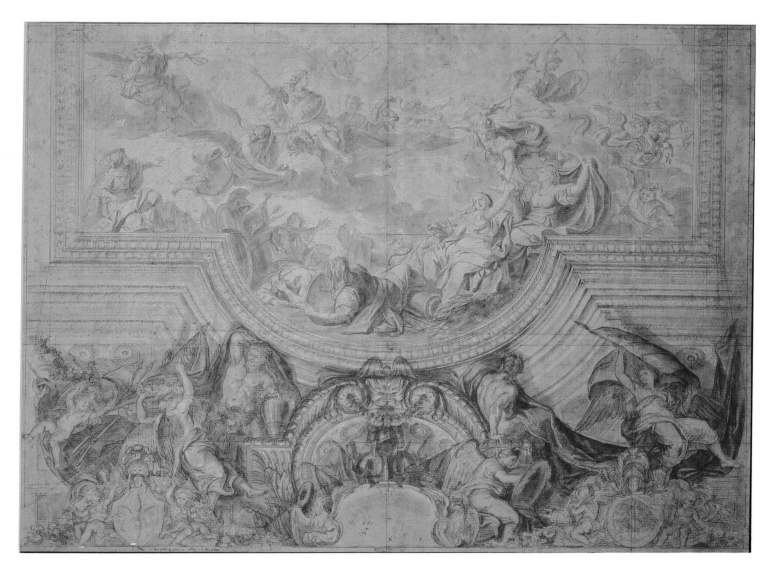

Paris, Louvre - on loan to the Musée national du château de Versailles.

ANDIRON

Red chalk. H. 0.317 x W. 0.235.

History
From the workshop of LE BRUN. Entered collections of
LOUIS XIV in 1690; paraphs of J. PRIOULT (L. 2953) and
A. COYPEL (L. 476) and R. DE COTTE (L. 1963); Museum
stamp (L. 1886)
Inventory 29551, Cabinet des dessins, LOUVRE.

Bibliography
MOREL D'ARLEUX, no. 10523/M - GUIFFREY, 1885, I, repr. p.
41 - JOUIN 1889, p. 635 - GUIFFREY and MARCEL VIII, no.
7914 - MARIE, 1972, II, p. 486.

Exhibitions
Versailles, 1963, no. 121, repr. - Paris, Orangerie, 1977-1978,
no. 290, repr.

As noted by JENNIFER MONTAGU (VERSAILLES exhibition, 1963), this design corresponds closely to the silver pieces described in *l'Inventaire général du mobilier de la couronne sous Louis XIV*, numbers 698 and 699 (J. GUIFFREY, vol. I, 1885): *" a pair of silver andirons, made by de Bonnaire, the bodies of which resemble ancient shields; on the front is an eagle, above are two dolphins embracing a globe upon which is seated a child holding a crown. The whole design is supported by a base comprised of two lion's paws. Four feet, 4 inches high, the total weight is 402m 1º 4ᵍ"*, or nearly 100 kilograms. While the name of the silversmith is known, along with the fact that he received payments between 1664 and 1675, recorded in the *Comptes des bâtiments*, nothing is known of the fate of these andirons.

By the end of 1689, a ruinous war had plunged the kingdom into serious financial difficulty; LOUIS XIV consequently decided to have all of his silverware melted down. THE MARQUIS OF DANGEAU noted in his journal on December 3:

"It is the King's wish that throughout the kingdom, all household silverware—mirrors, andirons, candelabras, and all kinds of vases—be melted down and brought to the Mint. To set a good example, he had all of his beautiful silverware melted down, in spite of its ornate workmanship."

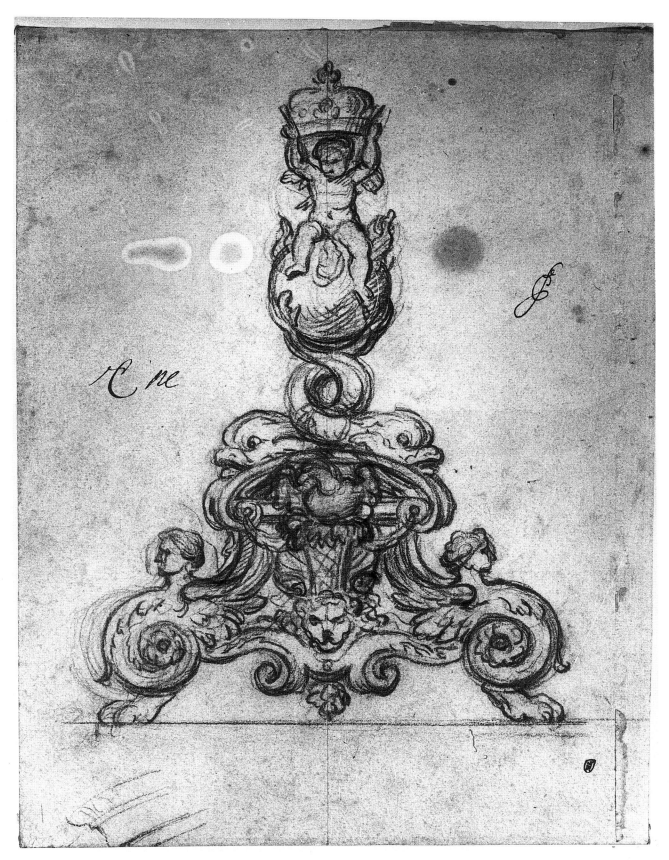

Paris, Louvre

CONSOLE TABLE

Red chalk; right half reproduced in counterproof from left half, partially reworked in red chalk. H. 0.205 x W. 0.329.

History
From the workshop of LE BRUN. Entered the collections of LOUIS XIV in 1690; paraphs of J. PRIOULT (L. 2953) A. COYPEL (L. 478) and R. DE COTTE (L. 1963); museum stamp (L. 1886). Inventory 29552, Cabinet des dessins, LOUVRE.

Bibliography
MOREL D'ARLEUX, no. 10523/N - JOUIN, 1889, p. 635 - GUIFFREY and MARCEL, VIII, no. 7907 - MARIE, 1972, II p. 486, repr.

Exhibitions
Versailles, 1963, no. 119, repr. - Paris, Orangerie, 1977-1978, no. 289, repr.

It was during the furnishing of VERSAILLES that gold- and silversmiths had the opportunity to exercise their talents. In his descriptive portrait of the silversmith CLAUDE BALLIN, CHARLES PERRAULT noted that *"the sculpture and engraving in the tables there was so admirable that even though they were of heavy, solid silver, the material accounted for barely one tenth of their value"* (*Les hommes illustres qui ont paru en France pendant le siècle, 1696-1700*). It cannot be conclusively determined that this plan for a console table had been prepared specifically for VERSAILLES.

As with other objects, the left half, rendered in red chalk, was reproduced in counterproof on the right half, and then partially touched up in red chalk. Three winged figures representing Sirens, linked together by garlands, support the table. The table legs end in lion's paws.

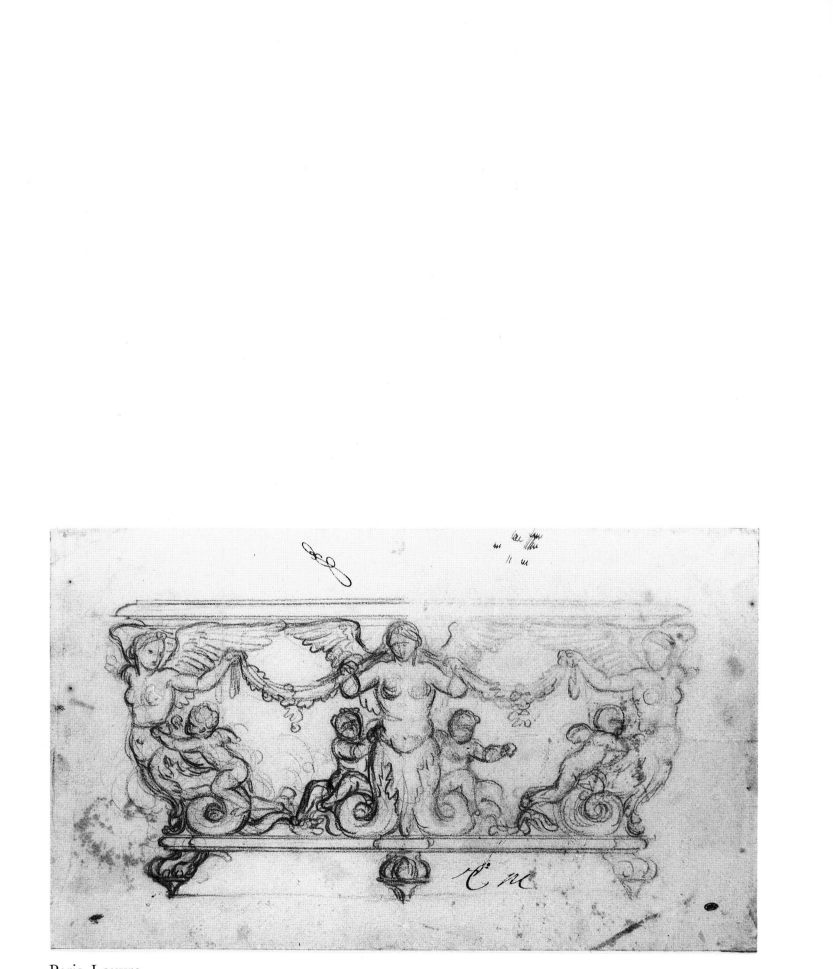

Paris, Louvre

MIRROR FRAME

Red and black chalk; the right half is a counterproof of the left, partially reworked in red and black chalk. H. 0.381 x W. 0.236. On the back, there is a study of a chandelier in red and black chalk.

History
From the workshop of LE BRUN. Entered the collections of LOUIS XIV in 1690; museum stamp (L. 1886).
Inventory 29555 Cabinet des dessins, LOUVRE.

Bibliography
MOREL D'ARLEUX no. 10524/L - GUIFFREY, 1885, I, repr. p. 281 - GUIFFREY and MARCEL, VIII, no. 7912 - MARIE, 1972, II, p. 486.

Exhibitions
Versailles, 1963, no. 122, repr. - Paris, Orangerie, 1977-1978, no. 287, repr.

JENNIFER MONTAGU (VERSAILLES exhibition, 1963) links this design to a description in *l'Inventaire général du mobilier de la couronne sous Louis XIV,* (published by J. GUIFFREY in 1885) under number 123:

"a huge mirror . . . made by Débonnaire . . . in a silver frame engraved with various ornaments, on the sides two large female figures behind whom there is a tent formed by a drapery, along the top the arms of the King between two allegorical figures representing Renown . . . this mirror is 10 feet in height, 6 feet, 4 inches in width, and weighs 1750 m. 4 o . Og. "

DÉBONNAIRE is also mentioned in the *Comptes des bâtiments du roi* of 1669 for the production of *"two large silver mirror frames."* According to MARIE (1972, II, p. 483), these mirrors were to be placed in the piers between two windows, above the consoles in the Great Apartment at VERSAILLES. They were delivered in 1682 following the death of the silversmith and complete payment was made to his heirs in 1683. These mirrors are not described but the similar weight (3.477 marcs, 5 ounces*

for both) would suggest that LE BRUN's drawing probably corresponded to this commission for VERSAILLES.

The left side of the drawing was transferred in counterproof to the right side, but the artist retouched a few elements, with variations, notably in the allegorical figure representing Renown bearing the King's arms. The woman on the left who was originally intended to be a full-length figure was also reworked so that it is cut off at the console. The model undoubtedly underwent numerous changes before being produced in silver.

* The marc weighs 244.72 grams and the ounce 30.59 grams.

Paris, Louvre

STATUES FOR THE PARK AT VERSAILLES
THE FOUR ELEMENTS

Black chalk, with grey wash. H. 0.344 x W. 0.499. Inscribed in pen and black ink, at the top and in the centre: *Les quatre éléments* at the bottom, under each of the pedestals: *L'air, le feu, l'Eau, la Terre.*

History
From the workshop of LE BRUN. Entered the collections of LOUIS XIV in 1690; paraph of A. COYPEL (L. 478) and R. DE COTTE (L. 1963).
Inventory 29793, Cabinet des dessins, LOUVRE.

Bibliography
MOREL D'ARLEUX, no.10731/25. - JOUIN, 1889, p. 609. - GUIFFREY and MARCEL, VIII, no. 5958, repr. - MARIE, 1968, I, p. 147. - SOUCHAL, 1981, II, pp. 254 and 321, repr.

Exhibition
Paris, Louvre 1985-86, no. 82, repr.

For the decoration of the water parterres under construction in front of the principal facade of the chateau, LE BRUN had conceived an extensive series of sculptures including twenty-four statues and four groups representing scenes of abduction. These works came under what was known as the *Grande commande de Colbert* and were assigned to the best sculptors of the period, with LE BRUN providing all of the drawings.

According to NIVELON, the iconographic themes in this group are intended to give an account of *"the bonds between the elements that constitute the universe."* Six groups of four statues each depict the Four Elements, the Four Seasons, the Four Hours of the Day, the Four Corners of the World, the Four Humours of Man, and the Four Poems. Each figure is represented in a pose and with accessories that take their inspiration directly from RIPA'S ICONOLOGIA (Rome, 1603) which had been translated into French in 1644. But RIPA's treatise was given a personal interpretation by LE BRUN and freely transposed by the talents of the sculptors. (See SOUCHAL for a comparison of LE BRUN's drawings and the completed statues.)

The Four Elements are personified by female figures. *Air* (sculptor - LE HONGRE) lifts up her veils as if ready to take flight; JUPITER's eagle has replaced JUNO's peacock (recommended by RIPA). *Fire* (sculptor - DOSSIER) holds an brazier and has one foot resting on a salamander, which is her symbol. *Water* (sculptor - LE GROS) is crowned with reeds and pours from a water-filled urn. *Earth* (sculptor - MASSOU), her hair adorned with flowers, holds a cornucopia.

By 1680, delivery of the white marble statues was underway, but the convoluted contours of the water parterres envisaged by LE BRUN were being modified. Moreover, it was feared that these two-meter high statues would obscure the imposing vista stretching out in front of the palace. They were therefore scattered throughout the park, with no consideration for LE BRUN's original groupings.

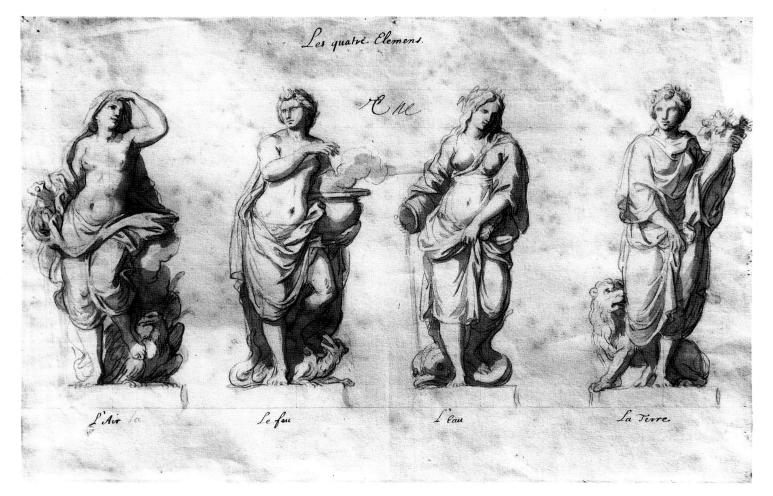

Paris, Louvre. On loan to the Musée national du château de Versailles

STATUES FOR THE PARK AT VERSAILLES
THE FOUR HUMOURS OF MAN

Black chalk, with grey wash. H. 0.324 x W. 0.486. Inscribed in pen and black ink, at the top and in the centre: *Les quatre complexions de l'homme*; at the bottom, under each of the pedestals: *le Colérique, le Sanguin, le Mélancolique, le flegmatique*.

History
From the workshop of LE BRUN. Entered the collections of LOUIS XIV in 1690; paraph of A. COYPEL (L. 478) and R. DE COTTE (L. 1963).
Inventory 29794, Cabinet des dessins, LOUVRE.

Bibliography
MOREL D'ARLEUX, no.10731/26. - JOUIN, 1889, pp. 608 and 609 - GUIFFREY and MARCEL, VIII, no. 5959, repr. - MARIE, 1968, I, p. 149 - SOUCHAL, 1981, II pp. 138, 173, 196 and 406, repr.

Exhibition
Paris, Louvre 1985-86, no. 83, repr.

For the decoration of the water parterres under construction in front of the principal facade of the chateau, LE BRUN had conceived an extensive series of sculptures including twenty-four statues and four groups representing scenes of abduction. These works came under what was known as the *Grande commande de Colbert* and were assigned to the best sculptors of the period, with LE BRUN providing all of the drawings.

According to NIVELON, the iconographic themes in this group are intended to give an account of *"the bonds between the elements that constitute the universe."* Six groups of four statues each depict the Four Elements, the Four Seasons, the Four Hours of the Day, the Four Corners of the World, the Four Humours of Man, and the Four Poems. Each figure is represented in a pose and with accessories that take their inspiration directly from RIPA'S ICONOLOGIA (Rome, 1603) which had been translated into French in 1644. But RIPA's treatise was given a personal interpretation by LE BRUN and freely transposed by the talents of the sculptors. (See SOUCHAL for a comparison of LE BRUN's drawings and the completed statues.)

The four Humours of Man are represented by strongly characterized figures. *The choleric* (sculptor - HOUZEAU) accompanied by a leaping lion, has a furious expression and holds a shield and sword. The *sanguine* (sculptor - JOUVENET) plays the flute and not the lute as proposed by Ripa. *The melancholic* (sculptor - LA PERDRIX) reads from an open book. *The phlegmatic* (sculptor - LESPAGNANDELLE) has his hands crossed on his chest and a tortoise at his feet.

By 1680, delivery of the white marble statues was underway, but the convoluted contours of the water parterres envisaged by LE BRUN were being modified. Moreover, it was feared that these two-meter high statues would obscure the imposing vista stretching out in front of the palace. They were therefore scattered throughout the park, with no consideration for LE BRUN's original groupings.

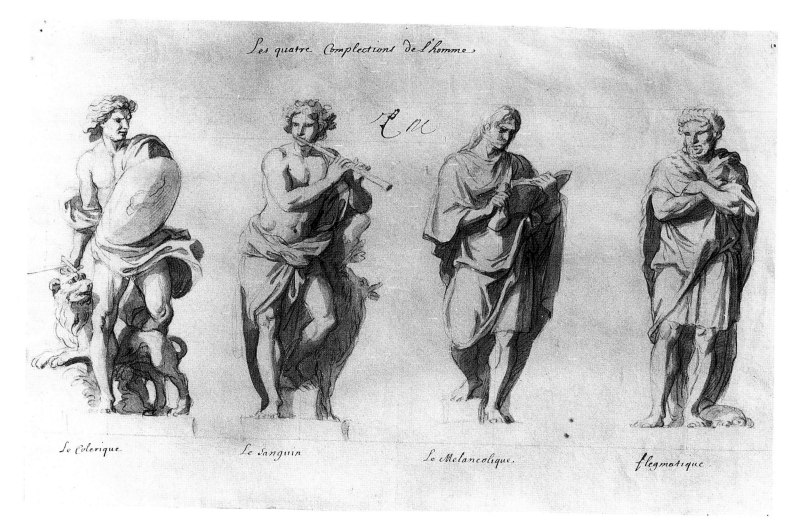

Les quatre Complections de l'homme

Le Colerique Le Sanguin Le Melancolique. flegmatique.

Paris, Louvre. On loan to the Musée national du château de Versailles

PLAN FOR A TRIUMPHAL ARCH FOR THE RUE SAINT-ANTOINE IN PARIS

Pen and brown ink, heightened with grey wash, for the architectural rendering; black chalk, heightened with grey wash for the decorative figures, whose features are engraved. Three sheets of paper joined together for the three arches. H. 0.387 x W. 0.526. Annotated in black chalk on the base of the equestrian statue: *Ludovicus XIIII*; along the bottom in black ink, scale for the entire length, noted in toises.

History
From the workshop of LE BRUN. Entered the collections of LOUIS XIV in 1690; paraphs of J. PRIOULT (L. 2953), A. COYPEL (L. 478) and R. DE COTTE (L. 1963); museum stamp (L. 1886). Inventory 30049, Cabinet des dessins, LOUVRE.

Bibliography
MOREL D'ARLEUX, no. 10726/63. - JOUIN, 1889, p. 631. - GUIFFREY and MARCEL, VIII, no. 5965 repr. s/le no. 8209. - PETZET, 1982, no. 2 p. 151, ill. no. 5. - PICON, 1988, pp. 223-230, ill. no. 193.

Exhibition
Paris, Louvre, 1972, no. 36.

In 1668, after the conquests of FLANDERS and FRANCHE-COMTÉ, COLBERT proposed that a triumphal arch be erected to the glory of the King, in the PLACE DU TRÔNE at the edge of the FAUBOURG SAINT-ANTOINE. The minister asked for submissions from LE BRUN, LE VAU and CLAUDE PERRAULT simultaneously. LE BRUN worked hard on developing his plan but in the end it was PERRAULT's proposal that was selected. The seven drawings of LE BRUN's plan at successive stages are in the LOUVRE. Two of them (Inv. 30.274 and 30.303), show a triumphal arch surmounted by an obelisk at each end. In the five other drawings, the project takes shape with variations on the structure and the decoration (Inv. 30.304, 30.273, 30.281, 30.043). LE BRUN's final proposal is presented here (Inv. 30.049).

The arch is more elongated than the triumphal arches of antiquity, with its central arch and two lower lateral arches. All of the decoration is LE BRUN's work. The statues represent his favourite figures: trophies, slaves, winged victories, and an equestrian statue of LOUIS XIV at the top. The Attic bas reliefs above the lateral arches depict the King's military and diplomatic triumphs and good deeds. These bas reliefs are very similar to the paintings on the ceiling of the Staircase of the Ambassadors at VERSAILLES. Among the scenes depicted are the King giving orders to his generals, the passage of the RHINE, the King reforming justice. At the bottom is the surrender of SPAIN and the King rewarding his army commanders.

A large-scale model was made of PERRAULT's project in 1670, and the orders were given to begin construction. But after COLBERT's death in 1683, work was abandoned and the project was never completed; the model and the work that had already been completed were destroyed in 1716.

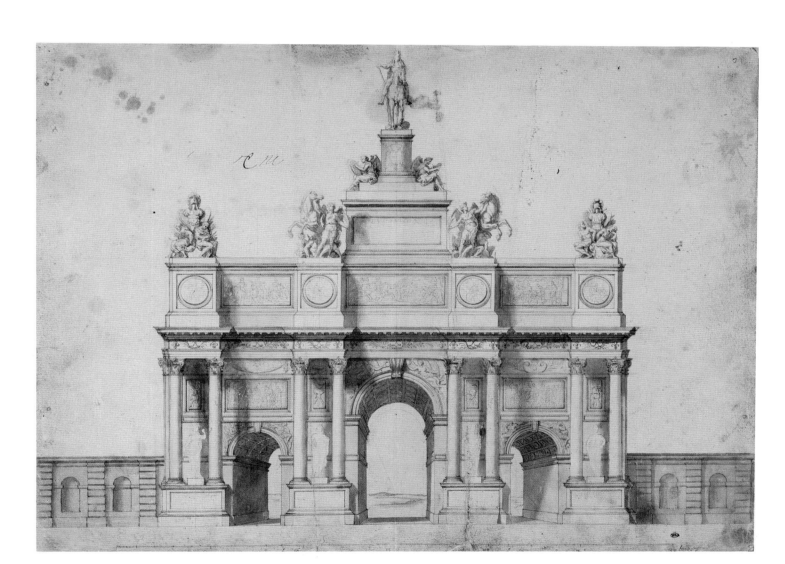

Paris, Louvre

PLAN FOR A WATER PARTERRE AT VERSAILLES

Pen and brown ink, over a black chalk sketch, with heightening in green and bistre wash. H. 0.153 X W. 0.527. Completely glued to backing. Framing outline in pen and black ink.

History
From the workshop of LE BRUN. Entered the collections of LOUIS XIV in 1690; paraphs of J. PRIOULT (L. 2953), A. COYPEL (L. 478) and R. DE COTTE (L. 1963); museum stamp (L. 1886). Inventory 30321, cabinet des dessins, LOUVRE.

Bibliography
MOREL D'ARLEUX, no. 10.733/44. - GUIFFREY and MARCEL, VIII, no. 8171. - WEBER, 1985, p. 78, ill. no. 155.

This drawing, produced in LE BRUN's workshop, was not done by LE BRUN himself. However, NIVELON's description (p. 265) confirms that LE BRUN himself conceived all of the elements.

The parterre, which extends across the gardens in front of the principal facade of VERSAILLES underwent numerous modifications. In 1674, a new plan, in which LE BRUN collaborated, was drafted. Far more complex than the large rectangular pool that it was to replace, it consisted of a round central component, framed by four other pools with winding contours, and formed a pattern inscribed within a square.

The drawing on the opposite page gives a perspective view of the parterre. Another drawing, also at the LOUVRE (Inv. 30.326) shows a plan of the same pools, marked off in toises, feet and inches, with a number of variations for the four lateral components.

To decorate this grouping known as the *parterre d'eau*, the best sculptors working with LE BRUN were given commissions for a large number of statues. The locations for the installation of these sculptures can be seen on the drawing. The first water parterre lasted until the completion of the GRANDE GALÉRIE in 1683, at which point MANSART and LE NÔTRE considered that the parterre, with its overly convoluted contours, was no longer in harmony with the chateau's new facade. It then took the form of two large rectangular pools, bordered with marble coping, which is how it appears today.

Paris, Louvre

FACADE FOR THE CHATEAU AT MARLY

Pen and brown ink, over a black chalk sketch; left half in black chalk only. Scale along bottom, in black chalk, calibrated in toises. Inscribed in black chalk, on the archways to the first floor, from left to right: A, C, B, E, D; upper right: 4 toises 39.
H. 0.yyy X W. 0.xxx.

History
From the workshop of LE BRUN. Entered the collections of LOUIS XIV in 1690. Paraphs of J. PRIOULT (L. 2953), A. COYPEL (L. 478) and R. de Cotte (L. 1163). Museum stamp (L. 1886). Inventory 30241, Cabinet des dessins, LOUVRE.

Bibliography
MOREL D'ARLEUX, no. 10726/18. - GUIFFREY and MARCEL, VIII, no. 8432. - MONNIER, 1972, s. no. 39. - MONNIER, 1977-1978, s. le no. 273. - BEAUVAIS, 1985-1986, s. le no. 81.

Exhibition
Versailles, 1963, no. 166, repr.

The château at MARLY, begun in 1678, with plans by MANSART, was to be a country residence; it consisted of a principal pavilion for the King and his family, and twelve single storey pavilions for his courtiers.

The drawing is an elevation of one of the facades of the royal pavilion. As in all of the structures at MARLY, the decoration of the pilasters, the reliefs above the windows, the doors and the pediments was painted in trompe l'oeil. Some time later, in 1688, the roof ornaments and the coping along the pediments were sculpted in stone.

Based on a architectural drawing, LE BRUN drew the details of the decoration seen here. The atlantes planned for the spaces between the last three windows to the right were replaced by Corinthian pilasters. This modification can be seen in another drawing by LE BRUN (Inv. 30 272).

The decoration of the pediments of the four facades was devoted to the theme of APOLLO's journey across the firmament. The MERCURE GALANT (November 1686, ii, p. 250-251) gives the following detailed description:
"... *Apollo appears in his chariot on the four pediments. In the first, he appears to ascend on the horizon like the rising sun. In the second,* *he is at noon. In the third he is beginning to descend towards the sunset. In the fourth, he comes to the end of his journey and is covered by the veil of night. All of the ornaments on the four facades are associated with the sun.*"
In the drawing of the eastern facade, AURORA and the ascending course of APOLLO's chariot are depicted on the pediment.

Completed in 1683, the château at MARLY was destroyed at the very end of the eighteenth century.

Paris, Louvre

PLAN FOR THE EAST FACADE ORIENTALE OF THE
LOUVRE

Pen and brown ink, with grey wash over black chalk drawing.
H. 0.461 x W. 1.471. Inscribed on the cartouche in the centre,
in pen and brown ink: *Ludovicus XIIII Gal. Rex.*

History
From the workshop of LE BRUN. Entered the collections of
LOUIS XIV in 1690.
Inventory 27641, Cabinet des dessins, LOUVRE.

Bibliography
MOREL D'ARLEUX, no. 6624. - JOUIN, 1889, p. 630. -
HAUTECOEUR, 1948, pp. 443-444 , repr. fig. 361. - LAPRADE,
1960, pl. VI 7. - WHITELEY and BRAHAM, 1964, pp. 360-361,
note 4 - PICON, 1988, p. 166.

Exhibitions
Paris, Louvre, 1972, no. 35.
Paris, Orangerie, 1977-78, no. 258, repr.

This drawing shows LE BRUN's plan for the east facade of the Louvre. Another drawing for the same project is in the ARCHIVES NATIONALES (0' 1667). At the LOUVRE, there is also a study for the central portion in which the pediment is sloped at the height of the balustrade and the statues are placed differently (inv. 30.227).

It was LE VAU, in 1657, who was first entrusted with the task of creating the east wing, which gives the LOUVRE its distinctive appearance. Later, COLBERT, who had become *surintendant des bâtiments*, called upon the talents of the flamboyant BERNINI, whose grandiose but unrealistic projects were the subject of much fervent discussion before being abandoned.

To break the impasse, COLBERT decided, in 1667, to entrust a committee, composed of LE BRUN, LE VAU and CLAUDE PERRAULT, with the design of the east facade. This committee developed two plans, one for a facade *"decorated with a row of columns forming a peristyle or gallery above the first floor"* and another for a *"simpler facade unbroken by columns."* (Excerpt from the *Registre du journal des délibérations et résolutions touchant les Bâtiments du Roi*, published by PIGANIOL de la FORCE.)

This drawing has traditionally been thought to be one of LE BRUN's plans that was rejected by the committee. LE BRUN was however also involved in the other plan featuring the colonnade, and one can see it, in fact, in the background of a frontispiece depicting the return of the FLANDERS campaign (Inv. 29.423). This frontispiece was designed for a thesis defended on August 29, 1668, by JEAN-BAPTISTE COLBERT, the minister's son and marquis of SEIGNELAY.

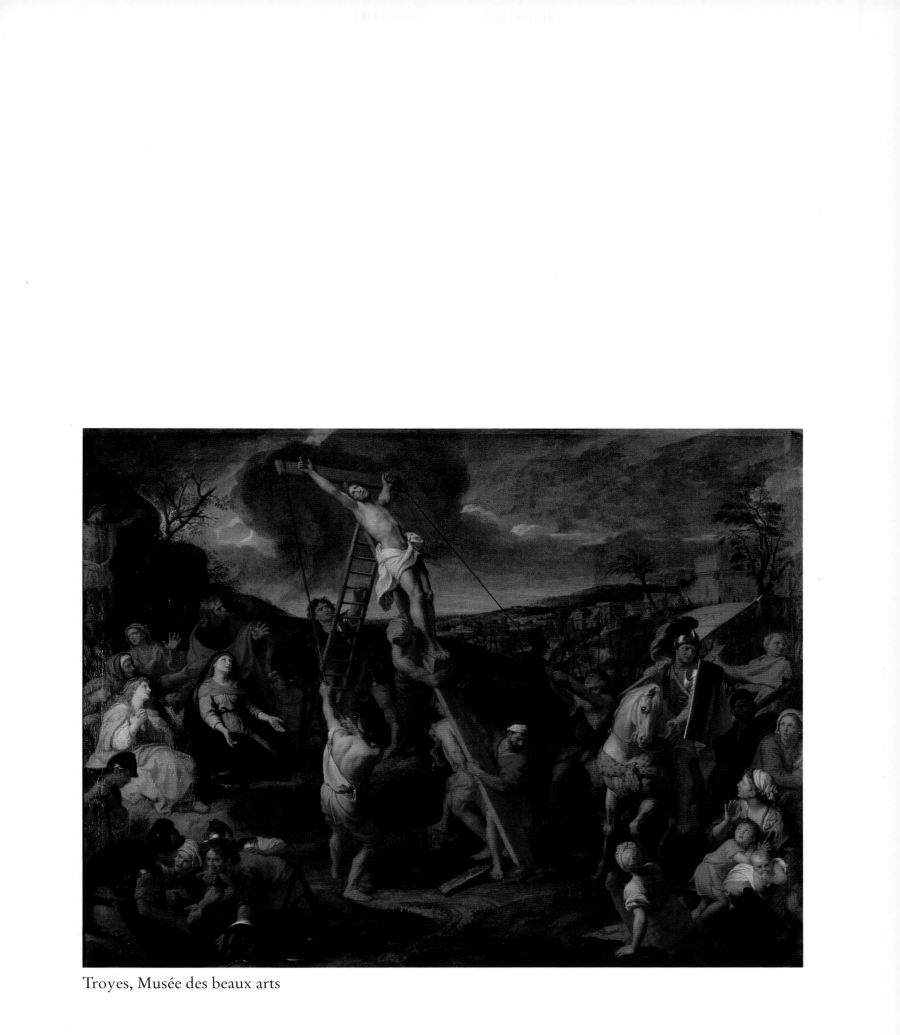

Troyes, Musée des beaux arts

THE CRUCIFIX OF THE ANGELS

Canvas, H. 1.74 x W. 1.28.

History
Collections of LOUIS XIV, VILLOT catalogue 111 nº 62. BRIERE
catalogue nº 501.
LOUVRE inventory 2886.

Bibliography
1889, H. JOUIN, p. 132-133, p. 332, p. 478. - 1909, P. MARCEL,
p. 51.

This heavenly representation of the subject differs markedly from the realism of paintings such as *Jesus on the Cross* or *Descent from the Cross* and yet it is unquestionably LE BRUN's work. It was this versatility of execution that amazed so many of his contemporaries such as FOUQUET and the QUEEN MOTHER. The latter often sought refuge at the CARMELITE MONASTERY on the rue ST. JACQUES where several of LE BRUN's works had been produced. When the Queen saw the paintings, she was astonished. She sent for the artist and asked him to translate to canvas a dream that she had had, in which JESUS CHRIST was represented on the cross, near death, surrounded by adoring angels, some kneeling on the ground and others flying. The crown of FRANCE was at the foot of the cross. "*And Monsieur LeBrun penetrated the Queen's pious thoughts so well that when she saw the painting, she confirmed that it resembled that which she had seen in her dream.*" (NIVELON, fol. 145). *The Crucifix of the Angels* was placed in the LOUVRE in the Queen's oratory. NIVELON relates that ANNE OF AUSTRIA rewarded the artist for this marvellous painting. The Queen's present consisted of "*a gold chain of great value and a diamond-studded watch.*" (fol. 147). The artist was immediately assigned the decoration of the Queen's oratory, where he painted *The Ascension of the Saviour* and *The Assumption of the Virgin.*

Thirty years later, on April 4, 1886, LE BRUN presented this same painting to LOUIS XIV. He took care, however, to extend the margins so that the canvas would look better in its new setting. This shows his concern for integrating a work harmoniously into its environment. The importance that he attached to his composition was not limited to the painting itself. The wall on which the painting hung was also a part of this composition, an extension of the work's artistic meaning.

Unlike most artists, LE BRUN did not have to resort to a middleman who would in turn sell his paintings to total strangers. The painter knew even before starting work who the painting was for and where it would be placed. Thus, each painting was created not only to reflect the personal tastes of its future owner but with an eye to its complete integration into its setting. It is quite unusual in the history of art to find a painter whose entire body of work reflects not his own ego, but the egocentrism of the numerous great figures for whom each work was created.

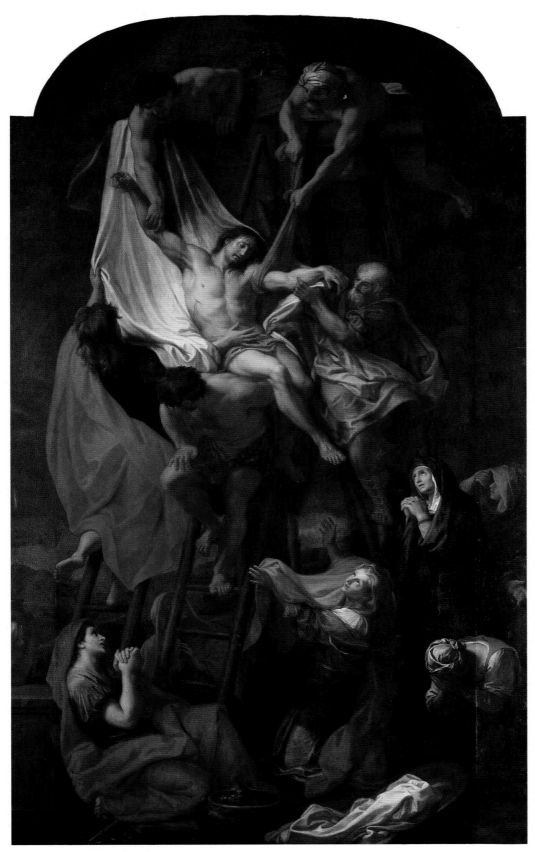

Rennes, Musée des beaux-arts

THE MEAL AT THE HOUSE OF SIMON
(OR MARY MAGDALENE AT THE FEET OF CHRIST)
(OR THE PENITENCE)

Canvas, H. 4.00 x W. 3.33.

History
circa 1653?: executed for the CARMELITE CONVENT of the rue SAINT-JACQUES; placed in the nave of the church.
1792: removed from the CARMELITE CONVENT and taken to the PETITS AUGUSTINS.
1793: sent to the MUSÉE CENTRALE DES ARTS on April 17; estimated value of 30,000 F in 1810.
1815: traded to the Austrian government for VERONESE's *The Wedding at Cana*.

Bibliography
1693, GUILLET (cf. *Mémoires inédits* 1854). - 1699, LE COMTE, v. III, section 1, p. 158. - 1700, NIVELON, p. 66-68. - 1716, LES CURIOSITEZ, p. 197. - 1749, DEZALLIER. - 1801-1810, LANDON, v. XIII, pl. 67. - 1804, MUSEUM FRANÇAIS, g. and engraving. - 1860, DU SEIGNEUR, n° 40. - 1854, MÉMOIRES..., p. 11. - 1883, ARCHIVES, v. II, p. 51, 269, etc. - 1889, JOUIN, p. 83-84, 470-471. - 1909, MARCEL, p. 168. - 1935, LEROY, p. 257, reprod. - 1944, BLUNT, p. 186. - 1960, CHASTEL, v. I, p. 69, fig. 30.

Exhibition
1963, Versailles, n° 19, repr.

Depending on which figure is singled out, this painting is variously known as *The Meal at the House of Simon* (for the host) *Mary Magdalene at the Feet of Christ*, (for the MAGDALENE expressing remorse over her sinful life) or *The Penitence*, (for the MAGDALENE washing CHRIST's feet during the meal). The incident is described in LUKE 7: 36-50:

> *One of the Pharisees invited Jesus to a meal; he went to the Pharisee's house and took his place at the table. A woman who was living an immoral life in the town had learned that Jesus was a guest in the Pharisee's house and had brought oil of myrrh in a small flask. She took his place behind him, by his feet, weeping. His feet were wet with her tears and she wiped them with her hair, kissing them and anointing them with the myrrh. . . . Then he said to her, 'Your sins are forgiven'. . . . 'Your faith has saved you; go in peace.'*

Since the painting was produced for the CARMELITES of the rue SAINT-JACQUES, LE BRUN could not deviate from the biblical version of the story. He nevertheless took care not only to convey the theological significance but to include details of archaeological interest as well. The smallest ornament was studied in painstaking detail. The guests recline on divans around a square table; their headdresses are unmistakably Jewish. The bands of colour and the fringes on the Pharisees' clothing are also historical details. In the foreground, a valet attends to the thurible traditionally used to perfume the air in the room. He gaily addresses the figure entering the room, whose outreached hand indicates his puzzlement over the incident disrupting the meal. On the floor there is a white cloth and the golden scraper known as a *strigil* that was used to clean and scrub the body, an allusion to the bath taken prior to the meal.

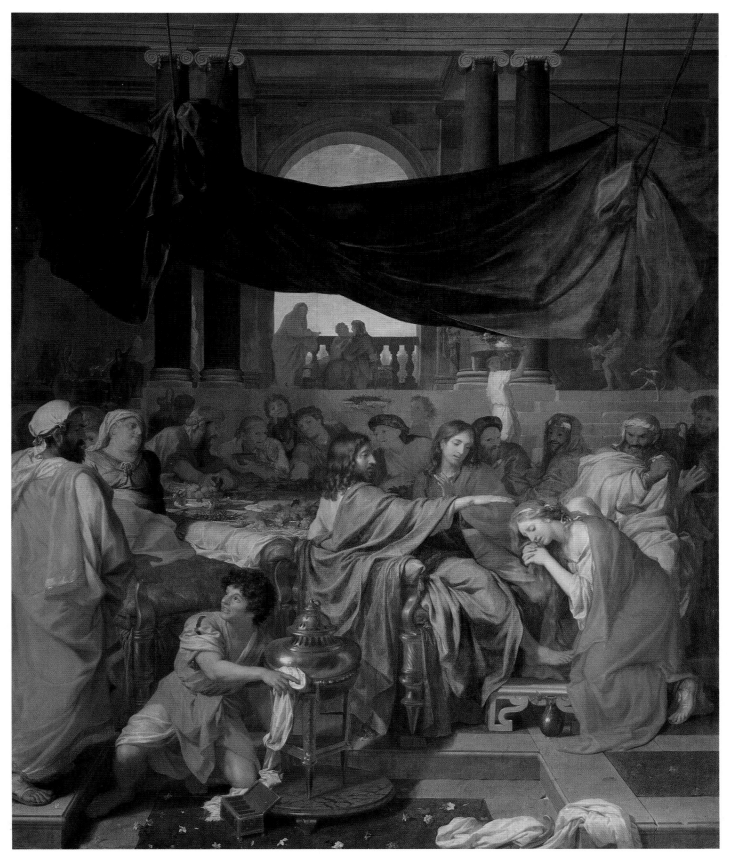

Venice, Accademia

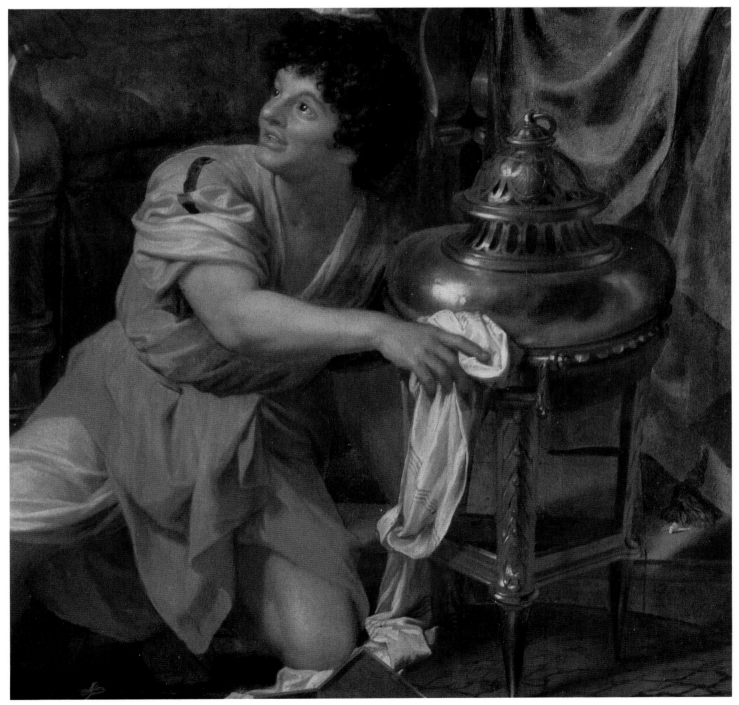

The Meal at the House of Simon (Detail)

THE ADORATION OF THE SHEPHERDS

Canvas, H. 1.51 x W. 2.13.

History
1689: painted by LE BRUN.
1695: at VERSAILLES in the Cabinet aux trois portiques.
19th century: placed in the Musée spécial de l'École française (n° 39 in the Catalogue of the Year X); from there it went to the LOUVRE. Estimated value of 8,000F in 1816. VILLOT catalogue n° 55. BRIÈRE catalogue n° 494.

Bibliography
1804, MUSEUM FRANÇAIS, f. 3 and engraving. - 1860, DU SEIGNEUR, n° 30.

Exhibition
1963, Versailles, n° 49, repr.

This painting, completed in 1689, some months before his death, is considered to be CHARLES LE BRUN's last important work. The old man's final days were taken up with BIBLE readings, which he then represented in his paintings. It is clearly a return to religious painting in the style of POUSSIN, but LE BRUN's compositional and design characteristics are easily recognizable. Far removed from the fiery and energetic expression of the *Battles,* the painting echoes the peaceful sensibility that the painter must have experienced at the end of his career. His solitude is similar to what POUSSIN experienced when he retired to his little country house in ITALY. The emotions expressed are accordingly gentler and more gracious.

The story as it is depicted in the painting is faithful to the version given in the BIBLE. However, as in many of LE BRUN's works, different episodes of the story are depicted as occurring simultaneously on the canvas. For instance, the heavenly light and the host of angels appear to the shepherds outside the stable at the same time as they are worshipping the newborn CHRIST. LE BRUN had often stressed to his students that, "*in some cases the painter must compress time if he wishes to be understood by the spectator.*" A new element in this composition is the blue banner that connects heaven to earth. There is no precedent in LE BRUN's work for this device, which had been used by primitive painters. LE BRUN had often been criticized by MIGNARD's supporters because the light falling on his figures was not always at the geometrically correct angle. In the *Adoration of the Shepherds,* LE BRUN took care to display several lamps for numerous lighting effects he wished to render so that MIGNARD's cohorts could find no fault.

The following passage from the BIBLE will shed light on the scene:

Now in this same district there were shepherds out in the fields, keeping watch throughout the night over their flocks. Suddenly an angel of the Lord appeared to them, and the glory of the Lord shone round them. They were terrified, but the angel said, "Do not be afraid; I bring you good news, news of great joy for the whole nation. Today there has been born to you in the city of David a saviour - the Messiah, the Lord. This will be a sign to you: you will find a baby wrapped in swaddling clothes, and lying in a manger." All at once there was with the angel a great company of the heavenly host, singing praise to God:
Glory to God in highest heaven, and on earth peace to all in whom he delights.

The usual French translation of this is "PAIX SUR LA TERRE AUX HOMMES DE BONNE VOLONTÉ." These words appear on the phylactery above the manger.

After the angels had left them and returned to heaven the shepherds said to one another, "Come, let us go straight to Bethlehem and see this thing that has happened, which the Lord has made known to us." They hurried off and found Mary and Joseph, and the baby lying in the manger. (LUKE 2: 8-16).

LE BRUN includes the ox and the ass in the scene. They are not mentioned in the GOSPEL, but seventeenth century Christian tradition recognized the presence of the ox and the ass at the Nativity. Since the Middle Ages, Christian doctrine has included them, based on ISAIAH 1:3.

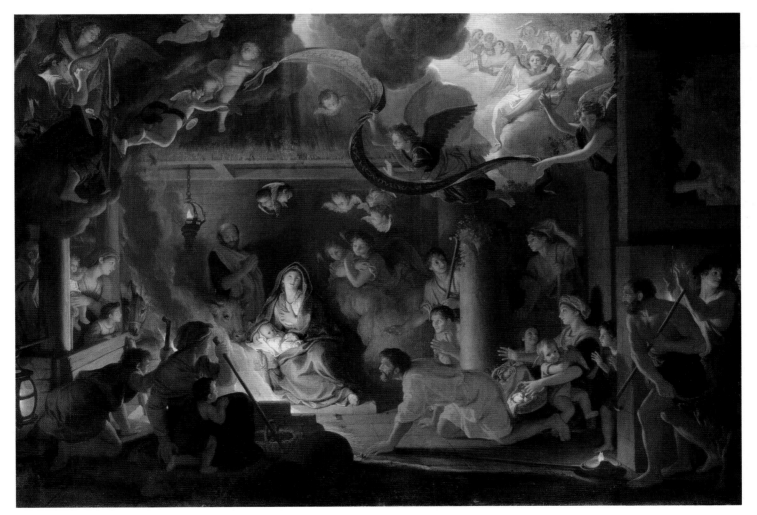

Paris, Louvre

THE HOLY FAMILY,
KNOWN AS THE SLUMBER OF THE CHRIST CHILD
OR SILENCE

Canvas, H. 0.87 x W. 1.18.
Signed with a monogram, dated 1655.

History
1655: signed by LE BRUN.
1693: mentioned in the Cabinet du COMTE D'ARMAGNAC, the King's grand equerry and governor of ANJOU.
1696: given to the King by the COMTE D'ARMAGNAC.
1793: entered the collections of the MUSÉE CENTRAL, and then the LOUVRE; estimated value of 15,000 francs in 1810, 7,000F in 1816.
VILLOT catalogue n° 56; BRIERE catalogue n° 495.

Bibliography
1693, GUILLET (cf. Mémoires inédits, 1854). - 1700, NIVELON, p. 56-57. - 1757, D'ARGENVILLE, p. 399. - 1804, MUSEUM FRANÇAIS, f. 2 and engraving. - 1853, COUSIN, p. 253. - 1854, MÉMOIRES INÉDITS, v. 1, p. 13. - 1860, DU SEIGNEUR, n° 32. - 1863-1866, LEJEUNE, v. I, p. 181. - 1889, JOUIN, p. 85, 468-469. - 1909, MARCEL, p. 157. - 1944, BLUNT, p. 186, pl. I.A.

Exhibition
1963, Versailles, n° 20, repr.

This work was completed at the height of the Regency period. With the death of LOUIS XIII, the kingdom came under the control of QUEEN ANNE OF AUSTRIA, LOUIS XIV's mother, and first minister CARDINAL MAZARIN. Since the kingdom had just weathered a turbulent political crisis, there were very few suitable subjects for painters of the period, other than the misfortunes and conflicts that were hardly flattering to the royalty. Since LE BRUN was already Painter to the King, he could not very well tackle contentious topics. Religion was therefore the only subject that was more or less neutral.

Given that LE BRUN was the master of symbolism, one might well wonder today if are thus no other messages to be found in a painting as simple as *The Holy Family*. The elements of the composition are easily identifiable from the religious texts of the time. ST. JOHN THE BAPTIST is in the foreground, dressed in his customary camel skin (MATTHEW 3:4; MARK 1:4). Behind him are his parents, ELIZABETH and ZACHARY. MARY, mother of the sleeping JESUS, is dressed in red and blue; his father JOSEPH is absent. The couple to the right is JOACHIM and ANNE, MARY's parents. The scene depicts the young JOHN THE BAPTIST adoring the CHRIST child. One might guess that LE BRUN was thinking of the verses from JOHN in which it is said that JOHN THE BAPTIST had clearly recognized that JESUS was in fact the MESSIAH. MARY's gesture for silence signifies that the time for the Revelation has not yet arrived. The shadows over the infant's head suggest that his divinity is *"hidden beneath the noble veil of flesh."* Only the head of MARY, mother of CHRIST the SAVIOUR, is illuminated.

In the *Great Battles*, LE BRUN used the character of ALEXANDER as an allusion to the King. In this painting of the *Holy Family*, would it not be possible to interpret certain symbols as a message announcing the arrival of LOUIS XIV, who was about to take control of the kingdom? It calls to mind the adoration of the magistrates for the young King upon his return to PARIS on October 21, 1652 (engraving by ALEXANDRE BOUDAN, rue ST-JACQUES).

Speculation on the parallels between religious history and the King's history is legitimate since this concurrence can be found in a number of LE BRUN's works. Since LE BRUN's fundamental principle was *"to say things"* through his art, it is interesting to follow his work through specific periods in French history in light of the different positions that he held. However, this must been done cautiously: a painting commissioned by a religious order is unlikely to reveal anything other than a theologically faithful rendering of the subject.

NIVELON was often ridiculed for reading contemporary significance into the symbolism of LE BRUN's religious paintings. He was, however, LE BRUN's student and we should perhaps therefore take this aspect of LE BRUN's work more seriously.

The composition technique in *The Holy Family* is typical of LE BRUN, with its figures positioned in a pyramid. The painter took care to lighten the weightiness of the composition by placing a door in the upper right corner of the background through which can be seen a brilliant sky. This technique recurs in most of his indoor scenes.

160

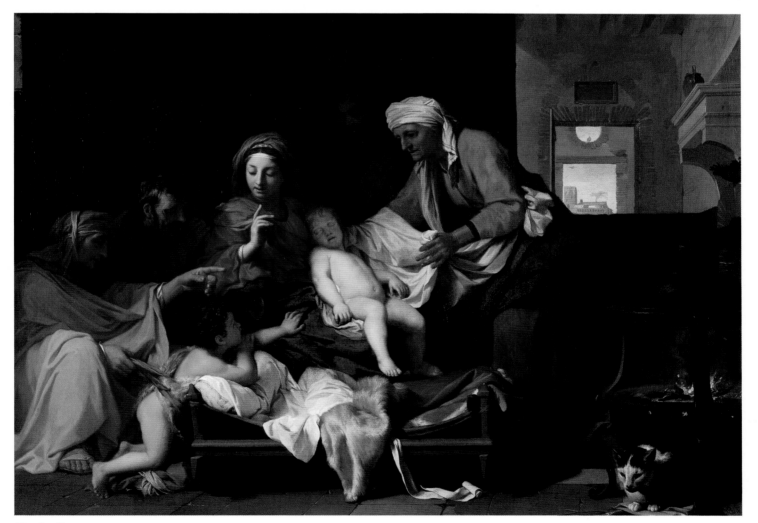

Paris, Louvre

Round canvas, 132 cm diameter.
Inscribed on the back *"Di carlo LeBrun 1793."*

History
1793: Acquired in FRANCE through the intercession of FRANCESCO FAVI, chargé d'affaires to GRAND-DUC FERDINAND III, with appraisal by a commission of the ACADÉMIE DES BEAUX-ARTS DE PARIS. Exhibited at the UFFIZI GALLERY on December 4, 1793. (See *Giornale di entrata*, 1793, n° 37.) Inventory number 1006.

Bibliography
1856, DUSSIEUX, p. 283 - 1860, DU SEIGNEUR, n° 12 - 1889, JOUIN, p. 97, 465 - 1909, MARCEL, p. 167, repr. p. 16 - 1922, LEMONNIER-MICHEL, p. 624, fig. 421 - 1925, SCHNEIDER, p. 143, 145 and fig. 82 - 1944, BLUNT, p. 189 - 1956, BOYER, *Les Relations artistiques entre la France et la Toscane de 1792 à 1796* in "LA REVUE DES ÉTUDES ITALIENNES" 1956, p. 23 sq.

Exhibition
1945, Florence, n° 33 repr. - 1963, Versailles, n° 23 repr.

JEPHTE, who lived around 1150 BC, was one of the most distinguished judges of the Hebrew people. According to the Scriptures,

"he was a valiant man. He was banished from his home because he was the son of a harlot. But his courage and his bravery gave him a certain reputation, and so it was that the people of Israel asked for his help in the face of a threat from a powerful enemy. Although unhappy with the conduct of his countrymen who had driven him away in his youth, Jephte finally yielded to their pleas and reluctantly decided to become their defender.

So, the spirit of the Lord came upon Jephte, and he travelled through Gilead and Manas'seh calling soldiers to arms. However, before waging war, he spoke to the Lord. He asked him for victory in battle and in a moment of rapture he promised to consecrate to God or to sacrifice the first living being he saw coming out of his house if he were victorious. Jephte's prayers were answered and the people were triumphant.

But, . . . at the moment of his arrival home, his daughter came dancing out of the house to the sound of timbrels; she was his only child, he had no other son or daughter save her. When he saw her, he rent his clothes in sorrow and said, "Alas, my daughter, you bring me to my knees and it is you that makes me unhappy. But I opened my mouth to the Lord and I cannot take back my vow." She answered him, "My father, you have opened your mouth to the Lord; do with me according to what has gone forth from your mouth . . ."

After lamenting her misfortune for two months, she threw herself into her father's arms, and he regretfully fulfilled his promise and consecrated her to service in the tabernacle."

LE BRUN has represented the scene of the sacrifice. The facial expressions reflect the emotions described in the Scriptures, in other words, the feelings of JEPHTE and his daughter have in effect changed from what they might have felt two months earlier. The painter conveys the resignation felt by the two main figures. JEPHTE lifts his eyes towards Heaven, disclosing his deepest feelings to the LORD. His daughter, with eyes lowered and hands clasped, prays silently. Her spirit seems to have already left this earth. The calm that prevails indicates that the initial violent reactions have subsided and that the painter wanted rather to heighten the spirituality of the act. It is probably for this reason that the weapon and the fire seem less important at first glance.

LE BRUN returns to diagonal composition here. The masses are grouped in a crescent slanting from upper right to lower left. It should also be noted that this is another example of his portrayal of major female figures in blue and white robes.

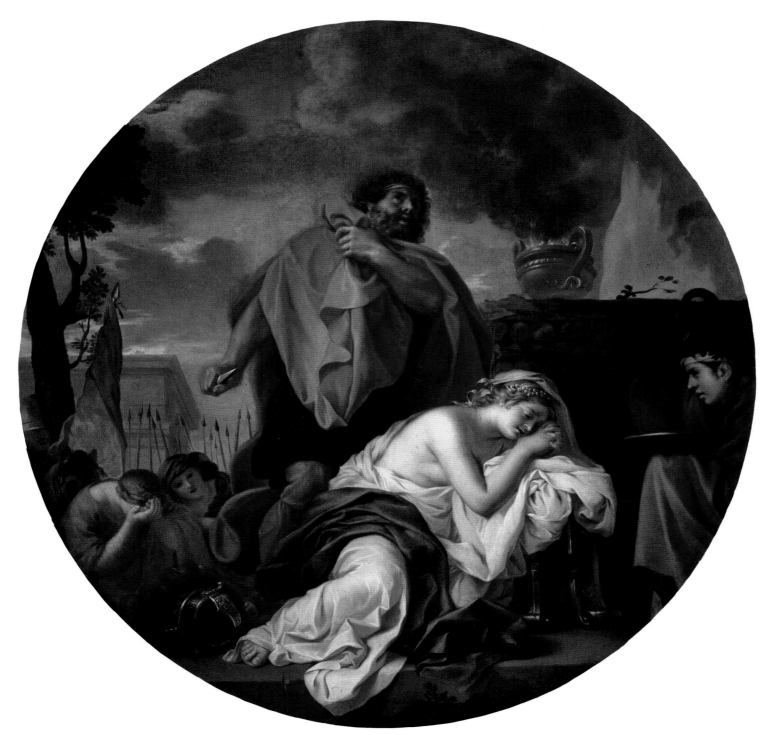

Florence, Uffizi Museum

THE DEATH OF CATO

Canvas, H. 0.96 x W. 1.30.

History
1646: Painted in LYON, upon LE BRUN's return from ITALY.
1693: Private collection, FAUBOURG SAINT-GERMAIN, PARIS.
1757: Mentioned by DÉZALLIER in the collection of TITON DU TILLET rue MONTREUIL, FAUBOURG SAINT-ANTOINE.
1763: April 30, donated to the ACADEMY by LA LIVE DE JULLY.
1793: Inventory of the year II, n° 80 (in the Great Hall of the Academy).
1795: Collections of the MUSEUM CENTRAL, and then the LOUVRE, (VILLOT catalogue n° 69; BRIERE n° 508); estimated value of 8,000 francs in 1810, 3,000 francs in 1816.
1896: Deposited at COMPIEGNE.
1953: Deposited at ARRAS.

Bibliography
1693, GUILLET, (cf. *Mémoires inédits*, 1854) - 1700, NIVELON, p.21 - 1757, DEZALLIER, p. 291 - 1801 - 1810, LANDON, Vol. XI, p.49, plate XXII, (engraved by LE BAS) - 1804, MUSEUM FRANÇAIS, d 4 and engraving - 1854, MÉMOIRES INÉDITS, vol. I, p. 7 - 1860, DU SEIGNEUR, n° 140 - 1889, JOUIN, p. 53, 509 - 1909, MARCEL, p. 10, 166 - 1912, LES ARTS, n° 128, p. 10, repr. - 1910, FONTAINE, (cf. 1930 edition, p. 146) - 1924, BRIERE, p. 314 - 1927, DIMIER, p. 31 - 1934, STERLING, p. 82 - 1944, BLUNT, p. 170.

Exhibitions
1956-7, Rome, n° 165 - 1958, Royal Academy, n° 38 - 1958, Petit palais, n° 76, pl. 28 - 1960, Washington, n° 95, repr. - 1963, Versailles, n° 9, repro.

This is another painting produced in the style of POUSSIN. The important lessons learned in Italy had a strong influence on LE BRUN's progress from the period of *Hercules and Diomedes* to that of *The Death of Cato*. The research is more extensive and the effects more elaborate. Once again there are elements in his composition which are directly related to ancient history.

A few words should be said about MARCUS PORCIUS, known as CATO OF UTICA, whose name comes from the latin word *"catus"*, meaning wise. CATO OF UTICA quickly discovered his calling as a defender of the oppressed. He was named a priest of APOLLO, one of the principal leaders of the Senate, and finally praetor.

The Romans pledged total allegiance to him since his first cause was to defend Roman freedom against CAESAR. Civil war was thus declared: *"As soon as the war had begun, he let his hair and beard grow, and the colour of his clothes revealed the sadness in his soul."* CATO suffered a number of setbacks in his struggle to preserve freedom. Finally, he seemed to have been defeated. *"Cato attempted to inspire resolution to fight to the death among the senators who had retreated with him to the city of Utica. But he was unable to share his courage with them, and he realized that the situation was hopeless. He took the necessary steps to arrange for the escape of all those wishing to flee the city. He himself did not seem to have any intention of leaving Utica. His friends and his son guessed the decision he had made.*

After retiring to his room, he read Phaedo, Plato's dialogue on the immortality of the soul. When he had finished reading, he asked for his sword to be brought to him. Shortly afterwards, he bade farewell to his next of kin and when everyone had left his room, he stabbed himself with his sword." It is this precise moment that is depicted in the painting. CATO's skin already seems to be whiter, blood spills onto the sheets, and both PHAEDO and the sword are represented. Some critics have found fault with the facial complexion as being a bit too robust for a dead man. Ancient history sheds the following light on the subject:

"As he fell, he knocked over the geometric table nearby; his son and his friends heard the noise and came running; they found him bathed in his own blood. They took advantage of his unconscious state to bandage the wound he had inflicted upon himself, but as soon as he came to, he violently pushed away the physician, tore away his bandages, ripped open his wound with his own hands, and died immediately."

It is thus the first part of the suicide that the above painting shows us. CATO is not yet dead and for this reason the painter conveys the warmth that still animates CATO's soul. LE BRUN so often referred to the soul in his lectures, and its presence is still felt here, thanks to the artist's palette and his powerful brush-strokes. To quote LE BRUN himself: *"My painting is less visual and more spiritual."*

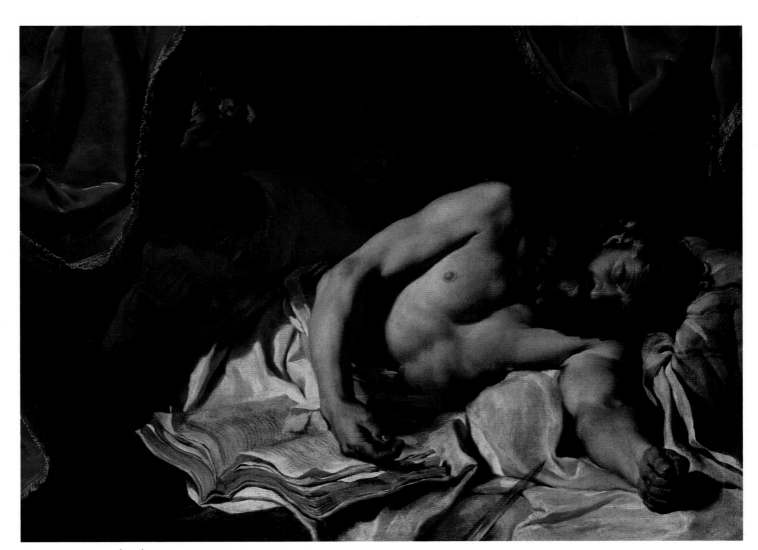

Arras, Musée des beaux-arts.

Canvas, H. 0.80 x W. 0.63.
Inscribed along the bottom: *C. LE BRUN PR. PEINTRE DU ROY TRÈS... [CHRESTIEN]*

History
1684: Sent to the GRAND DUKE OF TUSCANY in November; it arrived in FLORENCE three months later. Since then it has been in the self-portrait collection, *Galleria del Autoritratto*, nº 1858.

Bibliography
1693, GUILLET (cf. *Mémoires inédits,* 1854, v. 1, pp. 31, 46) - 1862, DU SEIGNEUR, nº 186 - 1889, JOUIN, pp. 307, 324-25, 414-24, 519 - 1909, MARCEL, p. 167; reprod. p. 4 - 1949, AUTORITRATTI *del Seicento e del Settecento,* ELECTRA, 1949, reprod. pl. 35.

Exhibitions
1945, FLORENCE, nº 34 - 1962, ROME, nº 127. - 1963, VERSAILLES, nº 43, repr.

This self-portrait was commissioned by GRAND DUKE COSIMO III OF THE MEDICI family of FLORENCE. LE BRUN waited almost two years before sending him this work. Since his time was taken up by numerous projects, in particular the GREAT HALL OF MIRRORS, he was unable to fulfil the Duke's wish before the end of 1684. His fear of sending the Grand Duke a work that was unworthy of him doubtless made him reluctant to get this project underway. The following excerpt is taken from the letter that accompanied the painting to FLORENCE:

Monseigneur:

If there is something that I can offer by way of an excuse for not having complied more promptly with your Serene Highness' request, it is the disgrace of sending him a portrait and copies of my works which would be unworthy of being presented before him.

Delighted by the painting, COSIMO III wrote to LE BRUN immediately and sent him a number of presents including four cases of wine, a case of sausages and two pieces of crimson damask, *"the most beautiful in the world."* Other letters followed, in which the Grand Duke reiterated his satisfaction with the work. LE BRUN was surprised to learn that his portrait was to be hung in the Grand Duke's personal offices. He wrote: *"It is not only because of Your Serene Highness' supreme rank that it is advantageous to please him; it is due principally to his universally recognized knowledge of the arts that his praise is exceedingly glorious."* What was thus most important to LE BRUN was the approbation of a great connoisseur of the arts such as COSIMO III.

The artist portrayed himself in bust; on his chest was a medallion bearing a portrait of LOUIS XIV *"framed in an oval of very rich and very sizeable diamonds".* This was, in fact, the medallion that the SUN KING had presented to LE BRUN as a token of heart-felt appreciation for his talent. It serves as a reminder of the supreme honour bestowed on LE BRUN and as affirmation of the highest royal favour.

LE BRUN needed no other devices to substantiate his renown. It is a humble portrait, with its neutral background, simple drapery, and the hands hidden. Nothing in the painting hints at his profession or his great accomplishments. All attention is drawn to the man; his glory is of secondary importance. The light is concentrated on his face and head, site of the soul and spirituality.

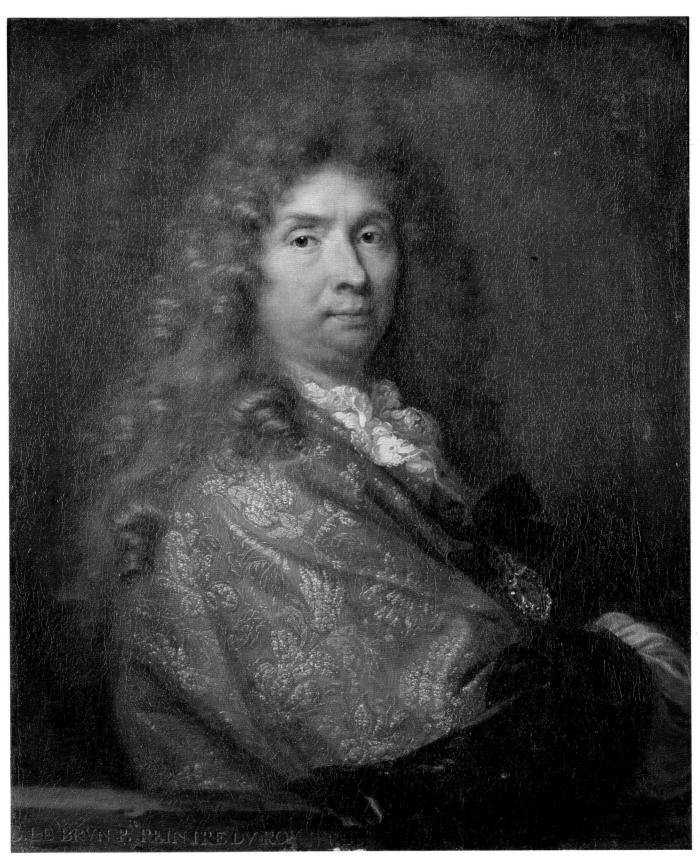

Florence, Uffizi Museum

MOLIÈRE

Canvas, H. 0.67 x W. 0.47.

History
Collection of K. KLATCHKOVA, MOSCOW.
1938: acquired by the PUSHKIN MUSEUM.

Bibliography
1986, CATALOGUE OF THE PUSHKIN MUSEUM, inventory
nº 3150.

Exhibitions
1915, MOSCOW, *Art in the Countries of the Alliance*
1955, MOSCOW, *French Art from the Fifteenth to the Twentieth Century*
1973, PARIS, MUSÉE DES ARTS DÉCORATIFS, *300th anniversary of the death of Molière*, nº 250.

The two areas of painting that did not interest LE BRUN were portrait painting, and still life and landscapes. He felt that it did not take a particularly imaginative mind to simply reproduce onto canvas a landscape or a face such as it appears before the artist. In this genre a painter could prove his talent as a technician but wherein lay the spiritual prowess or the creative genius? Still, LE BRUN did produce a number of portraits. It would have been difficult for him to refuse a commission from the King, a duke or a countess, for a portrait that they dearly wanted. The court esteemed LE BRUN as a noble, courteous and diplomatic person and it was not his style to offend an admirer over such a trifling matter. One can imagine him saying "Dear Madame, if such is your desire, I respectfully thank you for bestowing upon me the honour of pleasing you." This is probably how he came to paint portraits. Since he was frequently too busy with large projects, the idea of creating a portrait to satisfy a request or to give as a ceremonial gift must have been a fairly easy solution. When creating a portrait, LE BRUN dispensed with the time-consuming research, documentation, conception and reflection and launched directly into the actual painting. With his rapid execution and technical mastery he was able to fulfil the wishes of his clients or friends without adding to his already hectic schedule.

The portrait of MOLIERE presented here is consistent in style with numerous other known portraits by LE BRUN. It is simple and free of artifice; the great literary master is portrayed in all humility. There is no sign of the symbolic hand or pen. MOLIERE's success springs from his genius alone, which is accentuated by the radiant source of light at the temple, site of the soul's intelligence.

It would appear that this painting was produced in 1661, which is still acceptable given the type of costume and the subject's age. While there is no solid historical proof that LE BRUN wished to depict MOLIÈRE, the evidence seems nonetheless fairly clear. Moreover, several old engravings of MOLIÈRE reveal a clear resemblance with the subject of LE BRUN's painting.

MOLIÈRE was a great admirer of MIGNARD, LE BRUN's sworn enemy, which did little to foster friendship between the First Painter and the Actor to the King, especially in the last ten years of MOLIÈRE's life. Nevertheless, LE BRUN and MOLIÈRE did work together closely in 1660-1661. For example, at the great festivities at VAUX, the two artists were responsible for successfully organizing the sumptuous feasts commissioned by FOUQUET. There, MOLIÈRE presented *"L'École des Maris"* and *"Les Fâcheux"*, the sets for which were designed by LE BRUN. It is therefore entirely feasible that LE BRUN be commissioned to produce a portrait of MOLIÈRE during this period when the two artists were still working in close collaboration.

Moscow, Pushkin State Museum of Fine Arts

Canvas, H. 2.95 x W. 3.57.

History
1764: The painting is mentioned for the first time in print by GROSLEY in his *Éphémérides troyennes pour l'année bissextile MDCCLXIV*:
...M. le Duc displayed a painting very well-known in Paris, in which Chancellor Séguier, draped in a golden robe, seated on a white horse and accompanied by pages and standard bearers, appears amid the pomp that surrounds the highest judicial office...The artist has depicted himself as the equerry carrying the parasol (p. 77-78).
1793: The *Procès verbal des séances de l'Assemblée administrative du département de l'Aube* describes the portrait of SÉGUIER, conserved among the paintings at the CHATEAU D'ESTISSAC, adding that: "*we have admired the great mastery, the magnificent composition and the vigorous masculine touch of this great master.*" It mentions that the custodian had the canvases removed in order to roll and store them: "*The surfaces were cracked.*" Confiscated during the revolution, they were sent to TROYES.

1811: The collected re-edition of the *Éphémérides de P.-J. Grosley* (by L.-M. PATRIS-DEBREUIL, PARIS, in. 12_), which reproduced in volume II, on p. 262, the text quoted above, and adds that (p. 324): "*For some time, this masterpiece adorned the Salon de l'Hôtel de Ville: it was among the paintings that Troyes acquired during the Revolution, and which decorate this hotel and that of the prefecture.*" It seems that the painting, claimed by the owners of SAINT-LIÉBAUT, SÉGUIER's descendants, as a family portrait, has already been returned to them.

1942: The painting remained in the family until it was acquired by the LOUVRE, with the assistance of the AMIS DU LOUVRE, following the death of BARONNE DE LA CHEVRELIÈRE, née SÉGUIER.

Bibliography (in addition to works cited above)
1825, DESPORTES-BOSCHERON, the entry for Séguier in the *Biographie* MICHAUD, note ("*le chancelier Séguier à cheval prêt à entrer dans la ville de Rouen*".). - 1842, FLOQUET, Ch. *Diaire ou Journal du voyage du Chancelier Séguier en Normandie après la sédition des Nus-pieds*, published for the first time by CH. FLOQUET, ROUEN (rejects the preceding hypothesis). - 1860, DU SEIGNEUR, nº 167 ("*Entrée solonnelle du chancelier Séguier à Troyes en 1658*"). - 1889, JOUIN, p. 506 (The author quotes from NIVELON, bee seems to be unaware of the painting's existence.). - 1911, LAFOND (*entrance into Rouen*). - 1935, FRANCASTEL ("*L'Entrée du Chancelier Séguier à Rouen*"). - 1944, MORICHEAU-BEAUPRÉ (*Entrée de 1660*). - 1944, BLUNT, p. 192-3, p. IV-A (idem.). - 1945, BAZIN. - 1946, HUYGHE, RENÉ. *Nouvelles acquisitions. Departement des peintures*, in the "BULLETIN DES MUSÉES DE FRANCE", v. XI, nº 1 p. 17-24. - 1947, BEAULIEU, MICHELE. *Récents enrichissements du Musée du Louvre*, in "PRO ARTE", v. VI, p. 379-390, 12 fig. - 1953, BLUNT, p. 224, reprod. pl. 163 A. - 1957, TAPIÉ, p. 169-70, 344.

Exhibitions
1935. Exhibition of the ACADÉMIE FRANÇAISE, PARIS, nº 1114.
1937. PARIS, nº 89. Album, pl. 38.
1945. Exhibition "*Nouvelles acquisitions du Louvre.*"
1963, VERSAILLES, nº 22. repr.

The year in which the painting was done has been the subject of considerable discussion. Some studies claim that it was 1641 while others mention 1660-1661. Finally, in his catalogue of VERSAILLES, THUILLIER suggests that the date falls somewhere between 1653 and 1657.

It is difficult to determine the date of execution due to LE BRUN's changing style in the period preceding 1661. This is understandable since one of the principal qualities that LE BRUN's clients valued in this period was his ability to treat completely different subjects with different styles to match. FOUQUET had chosen LE BRUN precisely because he had been impressed by his versatility.

The question has often arisen as to what specific events LE BRUN wanted to commemorate in this composition. It can be categorically stated there were none. If the painter had wished to portray a specific entry of CHANCELLOR SÉGUIER, he would have made use of his great talents as a symbolist. This canvas is devoid of any symbol or accessory that might have hinted at a specific type of event. The painter chose to eliminate all artifice that would have detracted from the personal image of the chancellor. The eye is first drawn to the figure standing above his subjects. The parasols (symbols of protection) recall SÉGUIER's role as protector of the arts. The fact that the painter represented himself as an equerry carrying a parasol confirms this interpretation. Research is still underway in order to determine if other historic figures who, like LE BRUN, benefited from the chancellor's benevolence, can be recognized as pages and standard bearers in the painting.

The round-brimmed hat is the traditional cap worn by the chancellors of FRANCE. The ribbon of the order of the HOLY GHOST is probably the distinction that SÉGUIER prized above all others.

The composition technique here is similar to that of the self-portrait. It is simple, unencumbered by detail and concentrates directly on the qualities of the main figure.

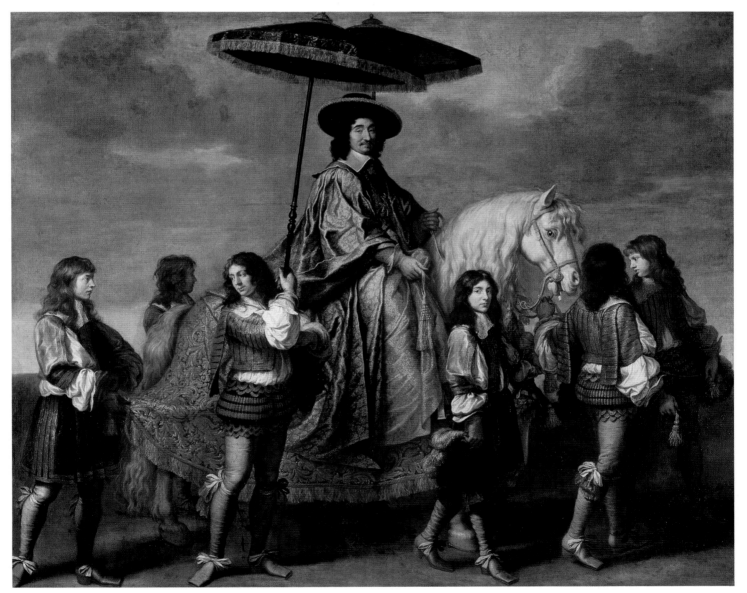

Paris, Louvre

HORATIUS COCLES
DEFENDING THE SUBLICIAN BRIDGE.

Canvas, H. 1.22 x W. 1.72; (a 9cm strip has been added along the bottom).

History
1804, DESENFANS Insurance list, no. 110.
1811, BOURGEOIS BESQUEST.

Bibliography
NIVELON, pp. 19-20; DUBOIS DE SAINT-GELAIS, 1727(and 1737), p. 97; DÉZALLIER D'ARGENVILLE, 1762, IV, p. 126; LÉPICIÉ, p.11; PASSAVANT, I, p. 65; WAAGEN 1838, II, p.388; WAAGEN 1854, II, p.348; DU SEIGNEUR, no. 144; JOUIN, pp. 53, 508; COOK, no. 244; BLUNT, 1944, pp.169-70. repr. p. 168A; MARCEL, p. 11; MURRAY, p. 77, no.244; MONTAGU, catalogue of exibition, Dulwich Picture Gallery, 1990, no 2, repr.

Exhibitions
1947, London, no. 26.
1990, London, Dulwich Picture Gallery, no. 2.

This is the painting that LE BRUN produced in secret and successfully passed off as a work by POUSSIN. The scene represents HORATIUS COCLES, a legendary hero who defended the new Roman republic against the Etruscan LARS PORSENA. The people of the country had found refuge within the walls of the city. The JANICULUM, the hill that dominates the landscape between the TIBER RIVER and ROME, had been taken by the Etruscans, so the wooden bridge had to be torn down. HORATIUS, who was in command of the group assigned to guard the bridge, exhorted his comrades stand their ground and to break down the pilings of the bridge. He himself stayed at the other end of the bridge and kept the enemy at bay until the bridge was just about to collapse. LE BRUN represented HORATIUS in his red cloak in the heat of battle. The crown of laurels above his head represents his victory. Further to the left in the mêlée there are two soldiers dressed in armour and plumed helmets. The first seems to attack an Etruscan from behind with his knife. The other, in the background, tries to control a horse ridden by an Etruscan. These two soldiers could be HORATIUS COCLES' comrades, SPURTIUS LARTIUS and TITUS HERMINIUS, as stated in ancient historical accounts. However, it would seem that LE BRUN wished to play down their presence in order to attribute the credit for the victory to the hero alone. Various versions in ancient texts state that HORATIUS COCLES was the sole defender of the Sublician bridge. The difficulty in identifying the two companions could arise from the fact that conflicting versions of the story were just as popular in the 17th century. In the background to the right, Romans are dismantling the bridge with huge spades. The river TIBER flows under the bridge; HORATIUS will later plunge into the water fully armed.

It is interesting to note what LE BRUN retained of POUSSIN's style in his later works. For example, in comparing this canvas to those of the *Battles of Alexander*, it can be seen that the backgrounds remained limited in perspective. Another point to note is the uniform paleness of the dead man between the legs of the Etruscan to the left. Based on this example a critic reproached LE BRUN, in the painting, *The Death of Cato*, for the colour in CATO's face.

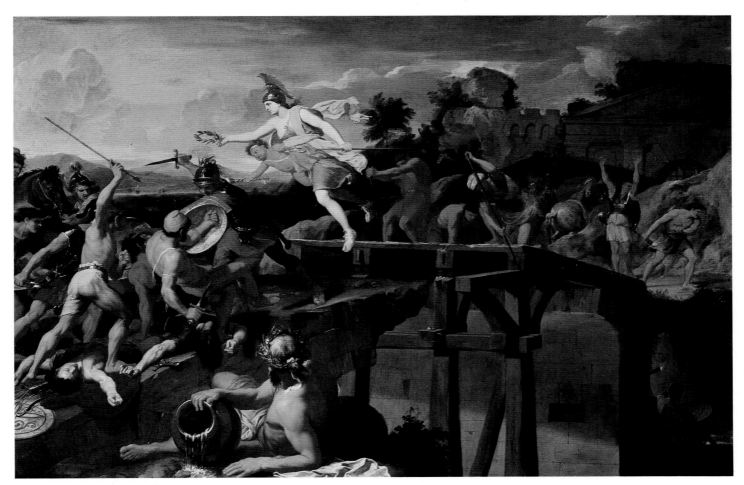

Dulwich Picture Gallery

Canvas, H. 0.96 x W. 1.34.

History
1643-45:Painted in ITALY, according to all biographers of the time. The painting must have been sent back to France, but Nivelon declared, *"I have not been able to gain any knowledge of this painting, nor have I located it."*

18th century: Collection of PESTRE SENEF; confiscated during the revolution.
19th century:LOUVRE (VILLOT catalogue, n⁰ 68) officially appraised value 1200 francs in 1810; 5000 francs in 1816.
1896: Deposited at the MUSÉE DE MÂCON.

Bibliography
1693, GUILLET, (cf. *Mémoires inédits*, 1854, I, p.7) - 1700, NIVELON, p.21 - 1802-1815, FILHOL, vol. X (1815), n⁰ 663, pl. - 1804, MUSEUM FRANÇAIS, d 7 and engraving - 1860, DU SEIGNEUR, n⁰ 145 - 1889, JOUIN, p. 52-53, n⁰ 508 - 1909, MARCEL, p. 10, 166 -1924, BRIÈRE, p. 314 - 1944, BLUNT, p.170 fig. II c.

Exhibitions
1958, ROYAL ACADEMY, n⁰ 123 - 1958, PETIT PALAIS, n⁰ 78 - 1961, ROUEN, n⁰ 43.
1963, VERSAILLES, n⁰ 6, repr.

All of LE BRUN's biographers mention this work, painted during his stay in ITALY. It may be recalled that at the time of his journey to ROME, the young LE BRUN was seeking mastery of POUSSIN's technique. This painting resembles POUSSIN's work to the extent that it would be difficult to tell whether it is by LE BRUN or POUSSIN, were it not for the realism of LE BRUN's style *"so foreign to Poussin during this period."* (THUILLIER, VERSAILLES catalogue, p.17).

MUCIUS SCAEVOLA was a legendary Roman hero.

"During the Etruscan seige of Rome, he decided to kill their king, Lars Porsena of Clusium. Mucius disguised himself in Etruscan dress and infiltrated the enemy camp where he discovered a crowd of soldiers awaiting their pay. A secretary seated at a table gave every appearance of being in authority. Assuming that this was the king, Mucius stabbed him. He was arrested and disarmed, and taken before Porsena for questioning. It was there that Mucius thrust his hand into the fire that had been lit for a sacrifice; he stared resolutely at the king during the ordeal.

Porsena was impressed by his courage and gave him back his sword. He took it with his left hand, hence the nickname "Scaevola" (left hand in Latin). Porsena and Mucius Scaevola became friends. The Romans and Etruscans declared a truce and the siege was lifted."

The above quotation sheds light on the historical context of the scene. LE BRUN's use of the expression of the passions is clearly in evidence here. In the foreground, he has reinforced the scene's shock value with the detail of the disemboweled sheep whose heart is being torn out for sacrifice. The painter thus heightens our sense of the intense pain that MUCIUS experiences by putting his hand in the fire. To the right, the body of the murdered secretary being wrapped in a shroud lends more tragedy to the situation. From his throne PORSENA motions to MUCIUS with his right hand to stop; the two men's eyes meet and the expressions speak for themselves.

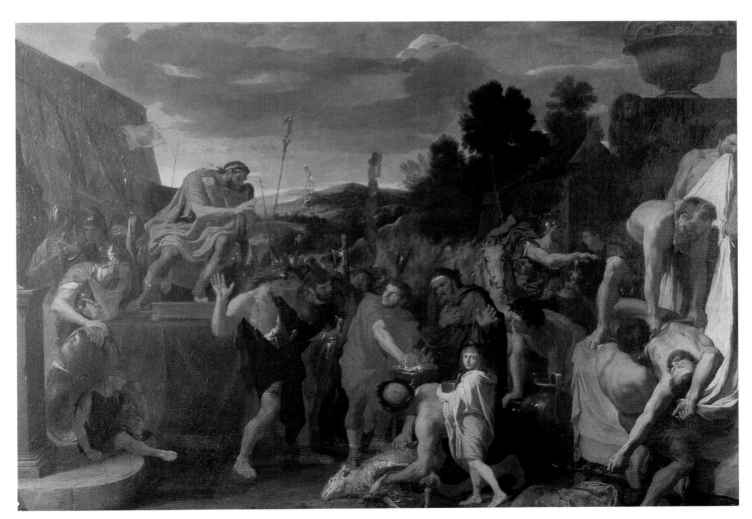

Mâcon, Musée municipal des Beaux-Arts

MOSES DEFENDING THE DAUGHTERS OF JETHRO

Canvas, H. 1.13 x W. 1.22. Matched set with *The Marriage of Moses and Sephora.*

History

1686: On April 4, LE BRUN delivered the painting to VERSAILLES. *"The King received the painting with much joy, and sent for Monsieur le Dauphin and Madame la Dauphine, and all of those of importance in the Court to come and see it."* (MÉMOIRE DE L'ÉCOLE DES BEAUX-ARTS, cf. *Mémoires inédits*, 1854)

17th - 18th centuries: Collections of the King, first hung in the CHAMBRE DU BILLARD, mentioned as being at l'HÔTEL DE LA SURINTENDANCE in 1760. During the Revolution, shown at the MUSÉE SPÉCIAL DE L'ÉCOLE FRANÇAISE at VERSAILLES. (Catalogue, year X, nº 34)
1814: Sent to MODENA in exchange for works that had not been returned to the government.

Bibliography

1693, GUILLET, (cf. *Mémoires inédits*, 1854) - 1700, NIVELON, p. 367-72 - 1742, PIGANIOL, 1742, p. 00-00 - 1804, MUSEUM FRANÇAIS - c 8, d and engraving - 1846, VALDRIGHI, *La Galleria Estense sotto il regno Francesco IV*, MODENA, *p. 5* - 1854, MÉMOIRES INÉDITS, vol. I p. 47, 60-64, 69-72 - 1854, CASTELLANI TARABINI, *Cenni storici e descrittivi intorno alle pitture della Reale Galleria Estense*, MODENA, nº 308 - 86, 302 - 84-85 - 1860, DU SEIGNEUR, nº. 7 and 8 - 1883, VENTURI, *La Realle Galleria Estense*, MODENA, p. 413 -1889, JOUIN, p. 331-33, 463-64, 643 - 1899, ENGERAND, p. 318-19 -1925, RICCI, *La R. Galleria Estense di Modena. Parte i. La Pinacoteca*, MODENA, nº 371 - 155, 372 - 156 - 1928, PEVSNER-GRAUTOFF, *Baroc malerei in der romanischen Länder*, Wildpark, POTSDAM, p. 313 - 1935, Zocca, *La Reale Galleria Estense di Modena*, coll. *"Itinerari"* 22 (reprod. of nº 00) - 1945, PALLUCCHINI, *I dipinti della Galleria Estense di Modena*, ROMA, p. 248, nº 573, (repr.) - 1955, SALVINA, *La Galleria Estense di Modena*, p. 24 (repr.)

Exhibitions
1963, Versailles, nº 44, repr.

This painting dates from the end of LE BRUN's life. Its dimensions are smaller and it was conceived not as a decorative component but rather as a complete work in itself; the painting was entirely executed by LE BRUN himself. As he neared the end of his life, he became more reclusive and secluded himself in his workshop to study the BIBLE. The following passage from EXODUS provides the background to the painting's subject:

> It came to pass that when Moses had grown up, he went out to his people and looked upon their burdens, and he saw an Egyptian beating a Hebrew, one of his people. He look this way and that, and seeing no one he killed the Egyptian and hid him in the sand. ... When Pharaoh heard of it, he sought to kill Moses.
> But Moses fled from Pharaoh, and stayed in the land of Mid'ian; and he sat down by a well. Now the priest of Mid'ian (JETHRO) had seven daughters; and they came and drew water, and filled the troughs to water their father's flock. The shepherds came and drove them away; but Moses stood up and helped them, and watered their flock.

To the right of the painting, the seven daughters of JETHRO are watching MOSES beat a shepherd. Here again LE BRUN renders the expressions according to the principles outlined in his lectures on the passions. He makes methodical use of geometry and resorts to the diagonal in the composition of this painting. In other works, such as *The Marriage of Moses and Sephora,* the composition is more vertically oriented. As in all of his historical paintings, LE BRUN liked to demonstrate his attention to historical detail. An interesting example of this can be seen in the sky where the two white birds are pursuing a strange creature. In examining ancient texts it is discovered that these are two ibises pursuing one of *"those flying snakes that lived in the desert of Mid'ian."*

It is understandable that CHANTELOU, when urged to give his opinion on the painting of *The Daughters of Jethro* he answered, *"Monsieur LeBrun has outdone the most skilful painters in all of Europe; but in this painting and in that of Christ on the Cross he has outdone even himself."*

Thus, at the end of his career, LE BRUN returned to the clear style of painting and the elegant forms he was fond of in the 1650s, the period during which he produced *The Meal at the House of Simon.*

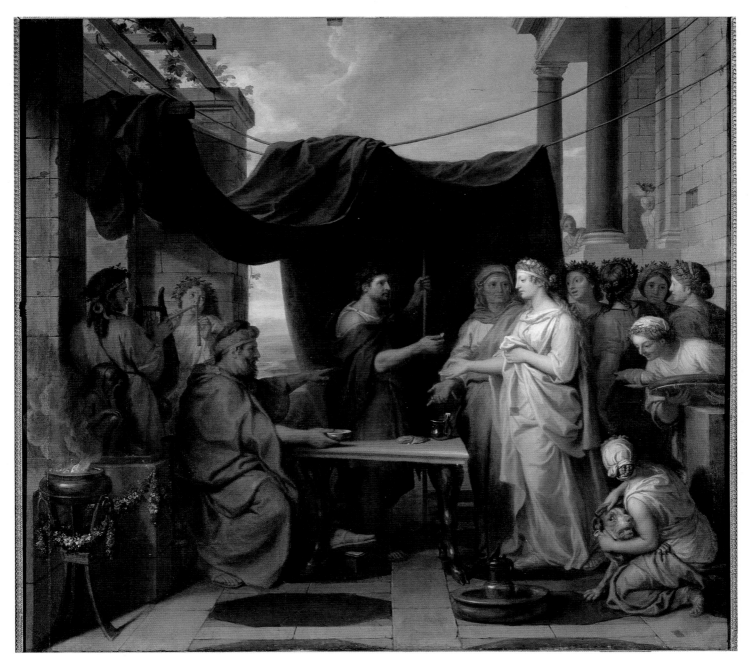

Modena, Galéria Estense.

MELEAGER AND ATALANTA AT THE HUNT

Canvas, H. 3.10 x W. 5.11.

History
Collection of JEAN VALDOR, then entered the collection of the painter ALEXIS SIMON-BELLE (1674-1734), purchased by one of his heirs, AUGUSTE-LOUIS BELLE (1757-1841) and sold to LOUIS XVIII in 1817.
VILLOT catalogue n° 75.

This canvas belongs to a group of eight destined for the collection of JEAN VALDOR. All eight tell the story of Meleager:
- *The Birth of Meleager*
- *The Meeting of Meleager and Atalanta*
- *Meleager and Atalanta at the Hunt*
- *Meleager Receives the Hide of the Calydonian Boar*
- *The Hide of the Calydonia Boar, Presented to Atalanta*
- *Meleager Slays His Uncles, Althea's Brothers*
- *Althea, Meleager's Mother, Throws the Magic Log on the Fire*
- *The Death of Meleager*

MELEAGER is the hero of the story known as *the Calydonian Boar Hunt* in the Iliad. LE BRUN, however, chose a derivative version popular in the seventeenth century over the PHOENIX version.

"The goddess Artemis, in her rage, had sent a huge boar to ravage the fields in the country of Calydonia. Meleager took it upon himself to rid the country of the monstrous beast and accordingly assembled a very large number of heros, including Theseus, king of Athens, his friend Pirithos, as well as Atalanta, daughter of Schoeneus. They all went in search of the boar, although some of the warriors were reluctant to hunt with a woman in their midst. Meleager was troubled by their resistance since he was in love with Atalanta."

Despite this, Atalanta was the first to wound the animal with an arrow. Amphiaraus, the son of Oeclus who had come from Argos, inflicted the second wound in the eye, and finally Meleager delivered the mortal blow with a spear in the side.

It is surprising that several biographers complained that LE BRUN was not a painter of women, that few were depicted in his works, and that his paintings were merely a pretext to glorify male society. In short, he was felt to be a misogynist. Were these accusations true, LE BRUN would not have depicted this version of the story of ATALANTA. Moreover, it should be remembered that he was the first to present a woman to the ROYAL ACADEMY OF PAINTING. On the other hand, it is true that very few paintings by LE BRUN have a woman as the principal figure.

ATALANTA, in the foreground, is dressed in a golden robe. The grace of her face and the gentleness of her hands represent Beauty. Her muscles and legs and the resolve with which she plants her foot on the ground represent traits of an alert hunter. MELEAGER is in front of ATALANTA, with a firm grip on his spear, ready to kill the ferocious creature.

In the middle ground, THESEUS, on horseback, is ready to intervene. In the background to the left, a man blows a curved trumpet to alert the other hunters and the dogs that victory is imminent. The beautiful landscape in the background was painted by BELIN, upon LE BRUN's request.

Paris, Louvre

THE DEATH OF MELEAGER

Canvas, H. 3.05 x W. 4.85.

History
Collection of JEAN VALDOR; became the property of painter
ALEXIS-SIMON BELLE (1674-1734); purchased by an heir,
AUGUSTE-LOUIS BELLE (1757-1841), then sold to LOUIS XVIII
in 1817.
VILLOT catalogue n° 76.

This painting is the last in a series of eight on the subject of MELEAGER that LE BRUN produced between the years 1658-1660.

It was said that MELEAGER was the son not of OENEUS but rather of ARIES.

"When he was seven days old, the Fates appeared before his mother, Althea, and foretold that the child's life was linked to that of the log burning in the hearth. Once the log was completely burned, Meleager would die. Althea quickly pulled the log from the hearth and put out the fire, and saved it in a chest that she kept carefully hidden away...When Meleager was a grown man, he killed a boar that had been terrorizing the kingdom. (See Meleager and Atalanta at the Hunt.) In return, he was given the animal's hide, which he immediately offered to Atalanta, as he was in love with her. Meleager's uncles were angered by this gesture, claiming that hide was rightfully theirs since they were his closest relatives among the boar hunters. In the violent fight that ensued Meleager killed his uncles, his mother's brothers. Outraged, Althea threw the magic log back on the fire and Meleager fell dead."

The seventh painting in the series shows ALTHEA throwing the log on the fire. The painting on the opposite page depicts MELEAGER's death. Deprived of his powers, his fate appears to be sealed. He is stripped of his armour and his weapon, both symbols of protection. His chest is bare, symbolizing the ultimate sadness. His pleading eyes are focused on ATALANTA, who sits weeping at his bedside. A doctor approaches and tries to find the dying man's pulse; warriors and women stand around in despair. To the left, one of MELEAGER's dogs howls while a woman weeps. Under MELEAGER's left foot can be seen the boar's hide. In the middle foreground, a servant girl seen from behind, brings him something to drink. On the table to the right, there is a shield representing a FURY with hair in the form of serpents, symbolizing malice. There is also a magnificent helmet, of which LE BRUN was so fond, decorated with an animal and feathers. The fine armour is very similar in style to that worn by HEPHAESTION in the painting *The Queens of Persia at the Feet of Alexander*. These two works were in fact produced at almost the same time.

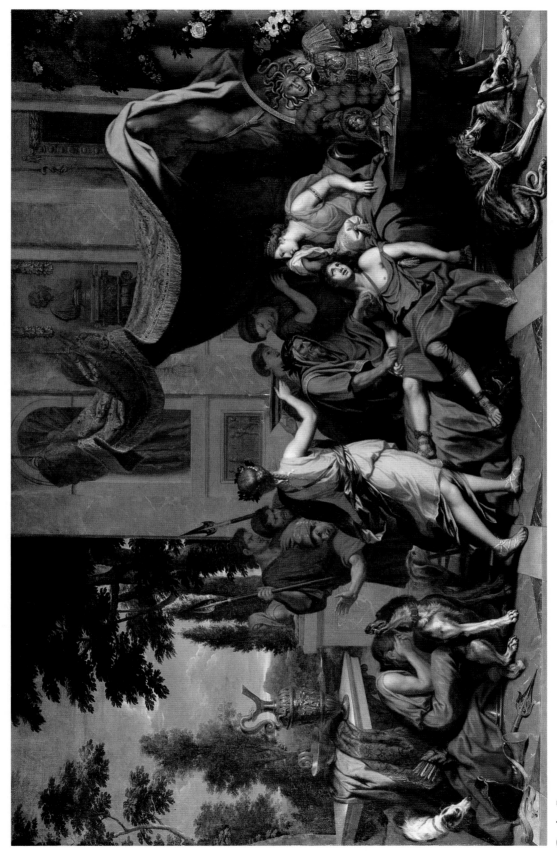

Paris, Louvre

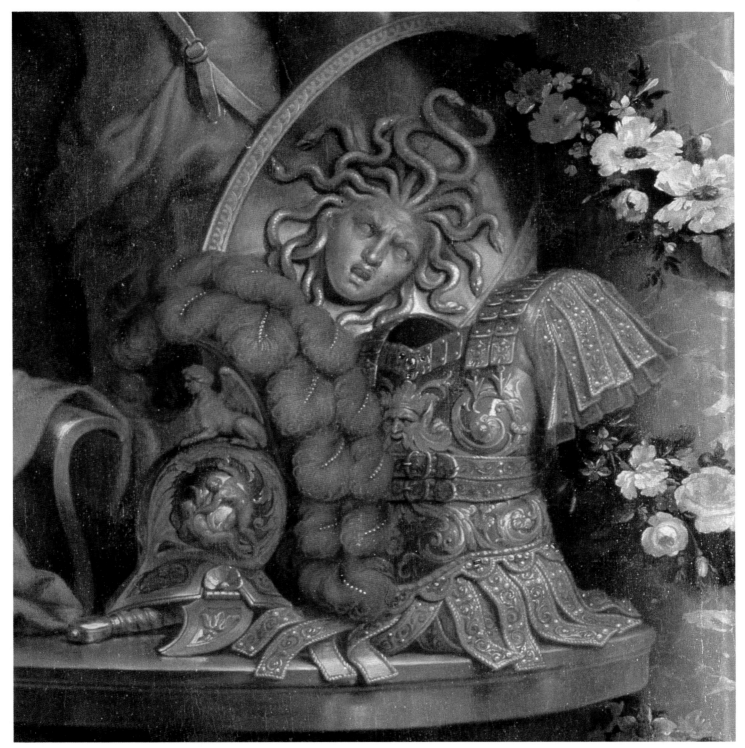

The Death of Meleager (Detail)

Canvas, 0.97 x 1.31.
Signed lower right: C. LE BRUN; dated MDCLXIV.

History
1780: Partial restoration of damage sustained during the revolution
1904: Reinforcement of canvas, CHATEAU LAMOTTE
1948: Acquired by ANDRÉ MARIE, president of the *Conseil des ministres et gardes des sceaux de France*
1983: Acquired from the minister's estate by a European dignitary

Bibliography
1965, ALEXANDRE ANANOFF, *Carnet de note sur Charles LeBrun*

The great classic legend of *Ariadne at Naxos* has been represented in almost all art forms over the centuries: in the tragedies of CORNEILLE and RACINE, the compositions of MONTEVERDI, HANDEL and STRAUSS, HAYDN's opera and the paintings of TITIAN, POUSSIN and LE BRUN. The highly emotional nature of the subject could not be ignored by these artistic geniuses who sought to establish an ever deeper relationship between human sentiment and their art. The scene is also related to the *Abandon of Armide*, a subject often treated by 17th century painters, including VOUET.

The characters in the scene are no less important than the subject. In the centre THESEUS, who is to become King of Greece, is the hero *par excellence* of the Athenians. He had partaken in so many glorious exploits that the Greeks considered him a great conqueror in the same league as ALEXANDER THE GREAT. There was even a proverb in ATHENS which aptly illustrated his importance: "*Nothing without Theseus.*"

To the right is ARIADNE, daughter of MINOS, king of CRETE, and to the left is her younger sister PHAEDRA. History reveals that

"*Minos was victorious in his attack on the kingdom of Athens* (ATTICA). *He demanded that King Ægeus provide him with seven maidens and seven youths every nine years or he would sack the city. These young Athenians were sacrificed to the Minotaur emprisoned in a labyrinth from which it was impossible to escape.*

Theseus, the son of Ægeus, saw this as an opportunity for a

new venture. He therefore requested to go to Crete with the young Athenians who had been chosen for the grim journey. Upon their arrival, Minos received the young people with courtesy and thus his two daughters met Theseus. Just then the goddess Aphrodite smote Ariadne with an irresistible passion for the Athenian prince. Ariadne offered him her assistance on the condition that he marry her and take her with him to his country; Theseus, naturally, accepted.

Ariadne then gave him a ball of thread (hence the expression ARIADNE'S WEB). *He tied one end to the inside of the door leading to the labyrinth and unwound it as he made his way through the maze. When he reached the heart of the labyrinth, killed the Minotaur and made his escape without any difficulty. He fled with his companions, taking with him Minos' two daughters, Ariadne and Phaedra* . . .

Theseus reached the island of Naxos at nightfall and stopped over. The next day he deserted Ariadne on the shore . . . "

The reasons for this vary according to different versions of the myth, but in the most popular version "*Theseus was forced to abandon the young woman upon orders from the god Dionysus*", better known by his Latin name, BACCHUS.

In a second painting that LE BRUN presented to the GRAND CONDÉ he depicted the meeting between ARIADNE and BACCHUS at

NAXOS after THESEUS' departure. NIVELON describes "*Bacchus in a golden chariot drawn by panthers*", the panther being the symbol of DIONYSUS/BACCHUS. LE BRUN makes a subtle allusion to the presence of the god by depicting his symbol on the swords of THESEUS and his companions. He thus shows the divine origin of the act without undermining the realism of this highly touching human scene.

In the immediate foreground a sword bearing the god's symbol indicates the source of the order. The first soldier's gesture with his left hand indicates that the order is irrevocable; he firmly grips THESEUS by the thigh, making it impossible for him to stay behind. In the centre, THESEUS, his head bowed down over his heart, lightly touches ARIADNE with his right hand as a sign of regret. His open left hand expresses his distress. The order is final: there is no turning back. This notion is reinforced by the interplay of feet that LE BRUN has so subtly represented. THESEUS has both of his feet blocked by those of his companions, thereby preventing him from returning to ARIADNE. The only choice left is therefore to return to the ship and leave ARIADNE behind. His companion consoles him from behind by placing his right hand on THESEUS' shoulder (symbol of friendship) and shares his suffering by placing his other hand over his heart (symbol of thwarted love).

The young woman has collapsed, overcome by sadness. LE BRUN describes this expression of passion in one of his lectures to the ROYAL ACADEMY:

> *This passion is also repre-*
> *sented by movements that seem to*
> *indicate a restlessness in the brain*
> *and a melancholy in the heart, for*
> *the eyebrows are raised higher*
> *towards the centre of the forehead*
> *than towards the cheeks; he who is*
> *distressed by this passion has trou-*
> *bled eyes, the whites of which are yel-*
> *low; the eyelids are lowered and*
> *somewhat swollen; there is a pallor*
> *around the eyes; the nostrils are*
> *drawn downward; the mouth is*
> *slightly open, the corners drooping;*
> *the head seems to rest nonchalantly*
> *on one shoulder; the colour of the*
> *face is leaden; the lips are pale and*
> *colourless.*
>
> *In sadness the pulse is slow*
> *and feeble; one feels as if the heart*
> *were bound with tethers and frozen*
> *by icicles that spread their chill to*
> *the rest of the body.*

ARIADNE's bare breast, which imparts this notion of coldness, and the cloak gathered tightly around her heart effectively illustrate the ideas that LE BRUN expressed in his lecture. The choice of colours and the cold textures of the young woman's cloak also give a strange glacial glow to her entire body. This sadness is not unlike the state of "*weeping*" that he also characterized in his lecture as having

> "*a strong red colour principally in*
> *the area of the eyebrows, the eyes, the*
> *nose and the cheeks . . . when the*
> *heart is despondent, all parts of the*
> *face are so as well.*"

The scene is stripped of any artifice that could detract from the strong emotion that the painter wished to communicate. The background is therefore neutral and the ship's

other passengers have been eliminated so as not to unnecessarily weigh down the painting.

Some historians reproached LE BRUN for having neglected an important mythological detail. When THESEUS arrived at NAXOS, his ship was supposed to be rigged with a black sail. LE BRUN was undoubtedly aware of this but concern for art over history was his fundamental rule. He would certainly have responded to such criticism as he did one day at the ACADEMY when a similar objection was raised by CHAMPAIGNE over details that POUSSIN had intentionally left out of a painting. He stated that first of all it was necessary to "*depict the principal action agreeably*" and this would mean rejecting "*bizarre objects that could lure the eye of the viewer and amuse him with trifles . . .*" He explained "*that the field of the painting is destined only for those figures necessary to the subject matter and those capable of ingenious and agreeable expression.*"

There is a very fine drawing of THESEUS in the LOUVRE (Inventory 29 777); although the positions are different, the character and his armour bear a strong resemblance to those in the painting.

The landscape in the background is reminiscent of that in *Moses Defending the Daughters of Jethro*, presented to the King 22 years later. The composition is practically identical but the landscape in *The Daughters of Jethro* was the work of LE BERNIN. Despite restoration work mainly to the area of the landscape, LE BRUN's touch is still evident in the background. The landscape is less detailed than LE BERNIN's and was rapidly executed. Hasty brushstrokes are apparent in the detail of the leaves to the right. LE BRUN was in fact not fond of landscapes. He preferred to devote his time to the principal scene, particularly to the details of the figures and their clothing and armour.

There is a very fine example of foreshortening here. The hands, arms and feet are represented from the most difficult angles and the precision of the details demonstrates to what degree LE BRUN had mastered this drawing technique. The general composition of the painting is classic LE BRUN: pyramidal composition, planes close together to reduce perspective, distribution of masses on the diagonal axis, lightening of the painting by a corner of uniform sky. The beauty of the armour is reminiscent of the *Battles of Alexander*, which were produced during this same period.

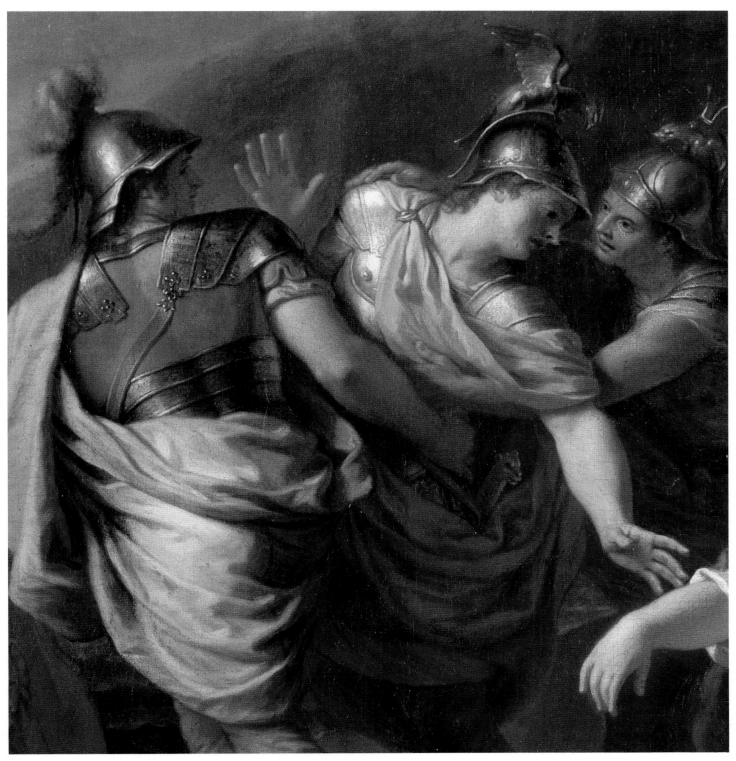

Theseus Abandons Ariadne at Naxos (Detail)

THE QUEENS OF PERSIA AT THE FEET OF ALEXANDER OR THE TENT OF DARIUS

Canvas, H. 2.98 x W. 4.53.

History
1660-1661: painted by LE BRUN upon request of LOUIS XIV. According to GUILLET SAINT GEORGES, "*in the year 1660, while he was at Fontainebleau, the King housed Monsieur LeBrun in the château, close to his apartments (...) and came to see him at unexpected moments while he had his brush in his hand ...*"; in 1661, according to the inscription accompanying EDELINCK's engraving, published during LE BRUN's lifetime, and which confirmed that the painting was executed at FONTAINEBLEAU in the presence of the King. According to NIVELON, LE BRUN put the finishing touches to it in PARIS. The painting was first placed in the *grand cabinet* of the King at the TUILERIES, then transported to VERSAILLES (restored in 1761 and 1788). It went directly into the collections of the LOUVRE (Notes of the MUSÉE CENTRAL DES ARTS, n° 18, VILLOT catalogue, n° 72, BRIERE catalogue, n° 511) and was appraised at 60,000 francs in 1810 and 1816.
1934: Deposited at VERSAILLES.

Bibliography
1663, FÉLIBIEN - 1682, *Mercure galant*, December, p.29 - 1688, PERRAULT, p. 220 sq. - 1690, *Mercure galant*, February, pp.260-61 - 1693, GUILLET (cf. *Mémoires inédits*, 1854) - 1696, PERRAULT, pp. 91-92 - 1699, LE COMTE, v. III, Part 1, pp. 161-62 - 1700, NIVELON, pp. 139-143 - 1731, VOLTAIRE (cf. note in 1733 edition) See GARNIER edition, v. VIII (1877, p.569) - 1751, VOLTAIRE - 1757, PERRAULT, pp. 216-20 - 1778, REYNOLDS (ed. DIMIER, *Discours sur la Peinture*, LAURENS, 1909, pp. 161-62) - 1801-1810, LANDON, v. II, pl. 57 - 1802-1812, FILHOL, v. I, pl. 55 - 1804, MUSEUM FRANÇAIS, b.7 and engraving - 1853, COUSIN, p. 253 - 1854, *Mémoires inédits*, pp. 24-26 - 1860, DUSEIGNEUR, n° 139 - 1863-66, LEJEUNE v. 1, p. 181 - 1889, JOUIN, pp. 133-37, pp. 497-98 - 1899, ENGERAND, pp. 319-20 - 1909, MARCEL, pp. 53-57 - 1927, DIMIER, pp.36-37 - 1933, RICHTER, p. 181 - 1953, BLUNT, pp. 243, 253, reprod. p. 164 - 1955, STEWART, passim - 1957, HARTLE, passim - 1959, POSNER, pp. 237-42.

This painting, first in the series on ALEXANDER, was the most famous of LE BRUN's works during his lifetime. The passage of time has stripped it of its original colour, and cleaning and restoration work have removed most traces of the qualities of the execution. It nevertheless remains very important historically, for it was on the strength of this painting that LE BRUN was nominated *First Painter to Louis XIV.*

The painting depicts ALEXANDER on the day after his victory at ISSUS. The Persian king DARIUS has fled out of fear of being killed by ALEXANDER and has left his wife and children in the encampment. After a night of victory celebrations, ALEXANDER and his closest companion HEPHAESTION pay a visit to the family of DARIUS the next morning.

On the left, HEPHAESTION, dressed in his traditional crimson mantle, is mistakenly assumed by the women to be ALEXANDER, and they throw themselves at his feet. When one of their eunuchs informs them of their error, ALEXANDER replies, "*You have not made a mistake, for he too is Alexander.*" (Les Conquêtes d'Alexandre, p. 268)

SISYGAMBIS, the mother of DARIUS, the first in this group of women, remains bowed down in front of HEPHAESTION, seemingly unaware of ALEXANDER's gestures and words. The latter speaks to QUEEN STATEIRA, DARIUS' wife, who holds her son OCHUS in her arms; both of them look at ALEXANDER as if to plead for his mercy. Beside her kneel DARIUS' two young daughters; one wipes her eyes beneath her veil and the other nervously prepares to join her hands in a gesture of supplication. Behind them are the handmaidens in turbans and the eunuchs. In the foreground to the right, one of the eunuchs is prostrate, his forehead in the dust in a final plea since he has no royal rank that could save his life.

It was customary for victors to help themselves to the wives and daughters of the enemy. ALEXANDER, however, set himself apart from ordinary conquerors by respecting the wife and daughters of the defeated king.

Two features of this painting warrant further discussion: the symbolism, and the colours or the palette.

The symbolism reflects the deep understanding that LE BRUN takes pains to

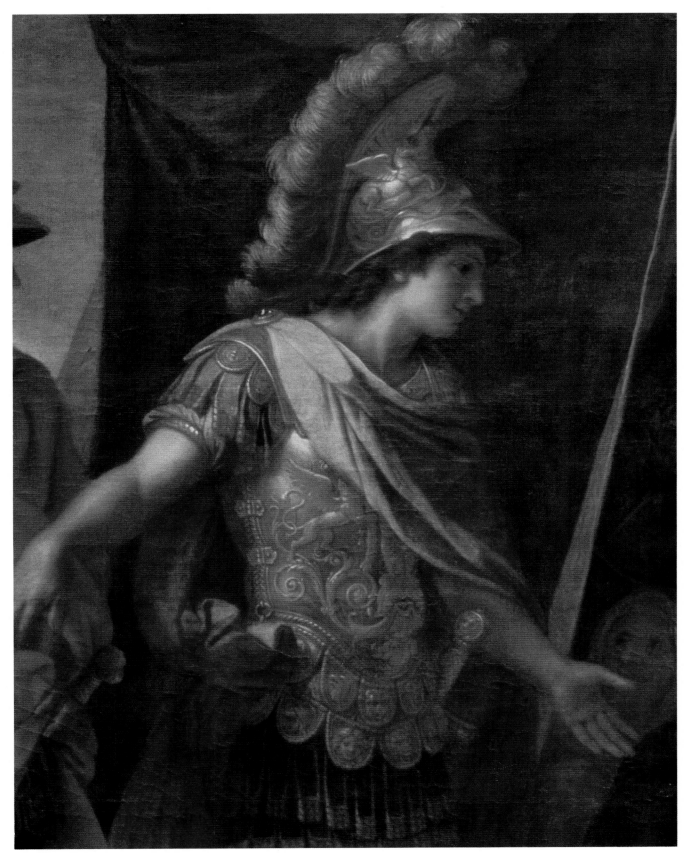

The Tent of Darius (detail)

THE TRIUMPH OF ALEXANDER or ALEXANDER'S ENTRY INTO BABYLON

Canvas, H.4.5 x W.7.07

History

1661-1665: This is one of the paintings depicting the history of ALEXANDER, commissioned following the success of *The Queens of Pers ia at the Feet of Alexander* in 1651. Despite its size, it was painted rapidly: on October 10, 1665, while visiting LE BRUN at the GOBELINS, LE BERNIN admired the painting, along with *The Passage of the Granicus* (CHANTELOU, 1665). In August 1673, the work was ex hibited in the Salon. It was greatly admired and was soon known throughout Europe, thanks to the tapestries produced by the GOBELINS and many engravings, which in turn generated numerous copies in the form of drawings, paintings and sculptures.

The original work, however, never found a specific destination. It was displayed in the CABINET DU ROI; towards the mid-eighteenth century, it hung in the APOLLO GALLERY at the LOUVRE. In the nineteenth century it was included in the museum's collections (VILLOT catalogue, no. 74; BRIÈRE catalogue, no. 513). In modern times it has been kept rolled up in the reserves and was only taken for t he 1963 exhibition of LE BRUN's works. Since 1989 it has been displayed, along with three other paintings of the history of ALEXANDER, in one of the largest galleries of the COUR CARRÉE at the LOUVRE.

Bibliography

1665, CHANTELOU, see 1877-1884, CHANTELOU, ed. LALANNE — 1679, *Mercure Galant*, August — 1680, TESTELIN — 1681, *Mercure Galant*, De cember - 1693, GUILLET, see 1854, *Mémoires inédits* — 1696, PERRAULT, pp. 91-92 — 1698, *Mercure Galant*, pp. 167-171 — 1700, LE COMTE, Vol. 3, Part 1, pp. 162-163 — 1700, NIVELON, pp. 173-184 — 1701, *Mercure Galant*, pp. 322-324 — 1752, DESPORTES, pp. 40-41 — 1763, DIDEROT, see SEZNEC-ADHEMAR edition, 1957, p. 221 — 1783, *Mercure Galant*, p. 91 — 1801-1810, LANDON — 1802-1815, FILHOL — 1807, TAILLASSON, pp. 175-177 — 1853, COUBIN, p. 253 — 1854, *Mémoires inédits*, Vol. 1, pp. 25-26 — 1860, DU SEIGNEUR — 1863-1866 , LEJEUNE, Vol. 1, pp. 180-185 — 1877-1884, CHANTELOU, ed. LALANNE, pp. 219-220, volume published in 1885 — 1878, GUIFFREY, *passim* — 1883, JOUIN, p. 127 — 1889, HARVARD-VACHON, p. 115 — 1889, JOUIN, pp. 215-218; 498-504, etc. — 1899, ENGERAND, pp. 324-325 — 1909, MARCEL, pp. 56-59, 103, 162 — 1922, LEMONNIER-MICHEL, pp. 621, 640, ill. — 1925, SCHNEIDER, pp. 127, 129, 144, ill. — 1927, DIMIER, p. 36, ill. — 1957, HARTEL, pp. 90-103 — 1959, POSNER, — 1963, THUILLIER, pp. 77-95 — 1964, THUILLIER, pp. 100-103, il l. — 1965, PARISET, pp. 148-149, ill.

Exhibitions

1673, PARIS, Salon du Louvre - 1963, VERSAILLES, no. 29.

This canvas, completed in 1668, is the last of LE BRUN's works based on the *Battles of Alexander*. Given that the first ALEXANDER painting was undertaken in around 1660, his speed of execution was prodigious. LE BRUN himself admitted that he put very little time into executing these colossal canvases, at a time in his life when he was "*the most occupied with the management of the King's works.*" (See *Mémoires sur les membres de l'Académie de peinture*, f.1, pp. 63-64.)

ALEXANDER was expecting a battle to gain control of the city of BABYLON. He knew that the great MAZAEUS, satrap of BABYLON, was to marry one of DARIUS' daughters and he assumed that his most recent victory surely must have fuelled DARIUS' future son-in-law's desire for revenge. However, to ALEXANDER's great surprise, the gates to the city opened and on each side incense was burning on silver altars. MAZAEUS, on horseback, dressed in robes embroidered in gold, advanced towards ALEXANDER with his two sons; they all dismounted to prostrate themselves on the ground . . . ALEXANDER thus made his triumphant entry into BABYLON.

LE BRUN's painting represents the scene in which ALEXANDER parades through the centre of the city in a silver-plated chariot pulled by two of DARIUS' elephants captured at ARBELLA. The elephants are blanketed in a tightly-woven cloth decorated with silver embroidery that also functioned as armour. Even their ears are adorned with jewels. At the head of a convoy, one of ALEXANDER's soldiers displays a silver shield mounted on a pike. LE BRUN always took pains to depict these shields as symbols of ALEXANDER's glory. Along the parade route there are silver tripods supporting censers in the form of rams' heads.

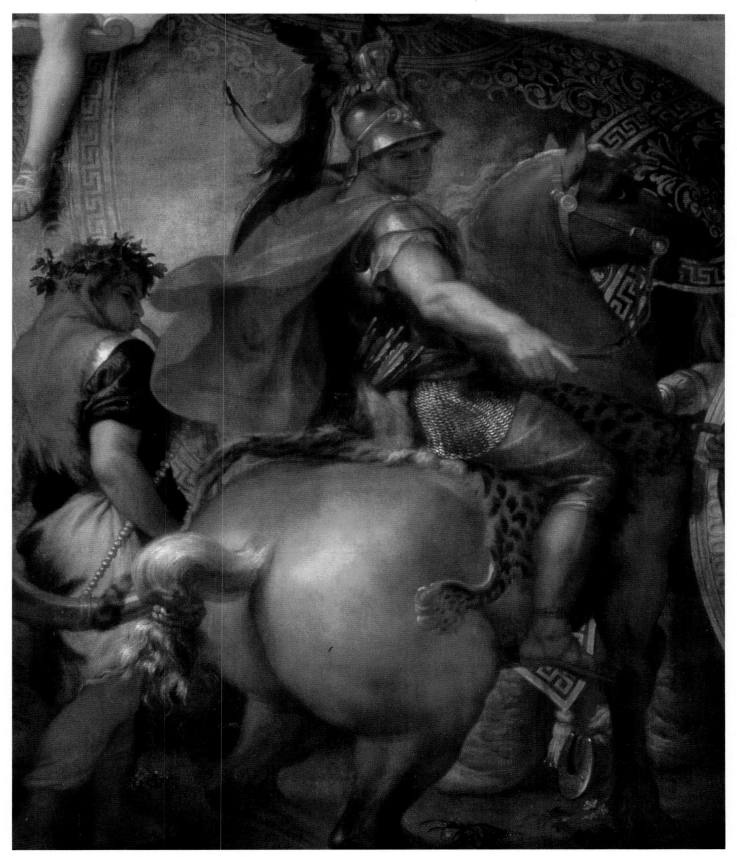

The Triumph of Alexander (Detail)

Canvas, H. 4.7 x W. 12.09

History
1661-1665: This painting was most likely begun around the same time as *The Triumph of Alexander* and, like the latter, was completed in October 1665, when LE BERNIN admired it at the Gobelins and even *"had it taken out into the courtyard"* to be able to see it in a better light. It then shared the fate of the others in the series. (See notes for THE TRIUMPH OF ALEXANDER.)

Bibliography
See bibliography for *The Triumph of Alexander*.

Exhibitions
1673, PARIS, Salon du LOUVRE - 1963, VERSAILLES, no. 30.

At the age of 22, ALEXANDER set out from the kingdom of MACEDON at the head of some thirty thousand men and fifteen thousand cavalry. This expedition was intended to avenge two incursions into GREECE made by the Persians under XERXES and DARIUS the First, incursions during which the Persians had destroyed temples, carried out horrendous massacres and taken numerous Greeks into slavery. He also intended to free the Greek cities of Asia Minor that had been conquered by the Persians.

MEMNON, the Rhodian general in the service of DARIUS, new king of Persia, was in command of the army that awaited ALEXANDER on the other side of the river GRANICUS. According to the advice of THUCYDIDES, *"he who attacked first would terrify the enemy."* ALEXANDER thus gave the signal to cross the river.

LE BRUN's representation is fairly faithful to historical accounts of the battle: *"the Persians' horses were covered with more blankets and covers than one would put on a bed."* This is the case with MEMNON's white horse in the centre of the painting. Similarly, the Persians have no armour; instead they wear *"linen tunics of such tightly woven cloth, that it was said that they were as tough as armour."*

It is interesting to note that MEMNON and the three captains that are charging ALEXANDER are wearing helmets, while the Persians have only turbans. LE BRUN was well aware of this difference since he had indicated so in studies done for this composition. For this detail he gave priority to artistic expression rather than historical accuracy. On this point both LE BRUN and POUSSIN were in agreement. *"Sometimes it is necessary to add or take away historical details in order to correctly convey one's thoughts."* One is reminded of LE BRUN's comment to the ACADEMY during a lecture by the painter CHAMPAIGNE who was criticizing, before the students, the inaccuracy of certain historical details in one of POUSSIN's works. LE BRUN retorted that *"we should recognize in principle the painter's absolute freedom when composing his painting."*

In the *Passage of the Granicus*, LE BRUN thus wished to emphasize his style by adding the famous helmets adorned with feathers or with animals.

In the centre is ALEXANDER on his horse BUCEPHALUS. He is recognizeable by his white-plumed helmet. He raises his sword against MEMNON, but at the same time a Persian has appeared behind him, brandishing a sword in both hands, intent on splitting open his head. A cavalryman in crimson has arrived just in time; he pushes away the warrior with his left hand and is about to kill him with a blow of the axe. *"You saved my life, Alexander said to him."* It was CLEITUS, the son of his childhood nurse. Further to the right, a helmeted Greek warrior carries one of the silver shields of ALEXANDER's special bodyguards, the

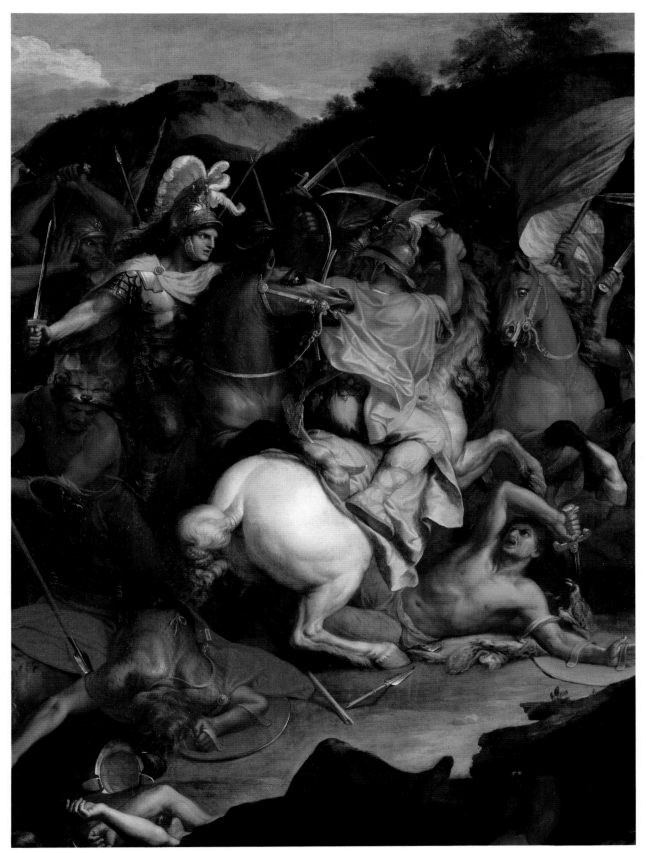

The Passage of the Granicus (Detail)

THE BATTLE OF ARBELLA

Canvas, H. 4.7 x W. 12.65

History
This painting was completed before February 1689, when BOURDON described it to the ACADEMY as a *"marvellous painting that Monsieur LeBrun has just created."* It shared the renown and the fate of the other canvases in the history of ALEXANDER. (See notes for *The Triumph of Alexander.*)

Bibliography
See bibliography for *The Triumph of Alexander.*

Exhibitions
1673, PARIS, Salon du Louvre - 1963, VERSAILLES, no. 31.

This painting depicts another of the major battles undertaken by ALEXANDER THE GREAT. He arrived at the foot of the Gordian mountains on the plain of ARBELLA in ASSYRIA with his army of forty thousand men. DARIUS had a million soldiers under his command. All nations from PONT-EUXIN to the furthest reaches of the Orient provided him with reinforcements, but these huge hordes were to prove DARIUS' downfall. For all the vastness of the plain of ARBELLA, DARIUS was only able to deploy a part of his immense army in the battle.

LE BRUN successfully conveyed the effect of having too many soldiers on the battlefield. However, if one is not aware of this historical detail of the story, one could easily criticize the scene as being cumbersome and confusing. It is hard to imagine one million fresh recruits in a huge army, lacking preparation and adequate communication, confronting ALEXANDER's valiant and loyal troops: chaos was inevitable. It is also worth remembering that LE BRUN's paintings were almost always created for the court nobility, the learned or the well-to-do, who had a certain level of cultural knowledge which enabled them to better understand and appreciate such artistic arrangements of ancient history.

LE BRUN is consistent in his composition technique. The painting is divided into several groups representing the different aspects of the battle. In the centre, ALEXANDER, riding his faithful horse BUCEPHALUS, makes his way towards DARIUS,

sword raised high. In the background, the old bearded man in white is the soothsayer ARISTANDER who points out the eagle hovering above ALEXANDER's head. This is the bird of JUPITER, whose son ALEXANDER was proclaimed to be, and it is also the symbol of victory. King DARIUS is getting ready to climb down from his gleaming chariot. His team of horses has been slain; another horse is being brought for him. To either side of the chariot, there are several howdahs mounted on the backs of elephants, filled with Persian soldiers hurling rocks and arrows. At the extreme left of the painting, a Greek warrior is about to cut off a man's head. The great strength of the blow evokes the force with which ALEXANDER's army cut through DARIUS' troops.

Many of the details are faithful to history, for example, the scythes installed in the hubs of the chariot wheels (bottom left). The silver shields of ALEXANDER's special bodyguards can be seen to the right. LE BRUN uses the same palette here as in all of his battle paintings, and the popular blue, purple and gold robes are also in evidence. The style of the armour and the magnificent helmets are both typical of LE BRUN's work.

In the foreground, one of DARIUS' lieutenants, with his sumptuous garments and feathered headdress, is a fine example of the expression of terror as described in LE BRUN's lectures to the ACADEMY. His fright, the speed at which he is fleeing and his obvious high rank all symbolize the total rout of the Persian army.

The Battle of Arbella (Detail)

ALEXANDER AND PORUS

Canvas, H. 4.7 x W. 12.64

History
This painting was apparently produced after *The Triumph of Alexander* and *The Passage of the Granicus* and was perhaps inspired by RACINE's *Alexander*, performed in December 1665. It was completed before August 1673, when it was displayed in Salon of the Louvre. It
then shared the fate of the others in the series. (See notes for *The Triumph of Alexander*.)

Bibliography
See bibliography for *The Triumph of Alexander*.

Exhibitions
1673, PARIS, Salon du LOUVRE - 1963, VERSAILLES, no. 32.

ALEXANDER continued his triumphant march across the land. He made several conquests without encountering any resistance from the rulers of the opposite camp. He then descended towards INDIA, founding ALEXANDRIAS everywhere he went. But further along, beyond the river HYDASPES, PORUS, a king renowned for his bravery, waited for him resolutely with his numerous allies.

From the outset of the battle, ALEXANDER's cavalry broke Indian lines. PORUS was defeated in his own encampment; seriously wounded, he was brought before ALEXANDER who asked him how he wished to be treated. *"As a king"* was the reply. Moved by the dignity of these words, he made a friend of his enemy from this moment on. He could afford to display such generosity, since *"he was master of the world, just as the oracle of Jupiter Ammon had predicted."*

The painting reads from left to right, much in the manner of a book. The first group to the left represents the finale of the battle where the Greeks gain undisputed control. The prisoners have their hands bound and are at the mercy of their victors. They are being dragged by horses; one of the captives is attached to a horse's tail. LE BRUN has effectively conveyed the cruelty of these hardened warriors.

In the centre, PORUS is supported by three soldiers. His legendary imposing stature has been well interpreted by the painter; one just has to compare PORUS' left hand with the soldier's head on which it is resting. Behind Porus, soldiers are showing signs of fatigue. The sun shines on ALEXANDER; he is followed by HEPHAESTION, whose crimson mantle is historically accurate. Further to the left, a chariot is being brought for the wounded king. In the background on the far right there is a golden statue of HERCULES. LE BRUN has taken pains to remind us that the meeting between ALEXANDER and PORUS took place in the Indian camp, for it is known that Eastern people had a custom of bringing images of HERCULES to the battlefield as a token of victory. Indian tents spread off into the distance.

Photographic credits

The majority of the photographic reproductions in this work were produced by the
RÉUNION DES MUSÉES NATIONAUX IN PARIS, with the following exceptions:

ARCHIVES NATIONALES DE PARIS, III-1

BULLOZ, IV-3

CARPENTIER, Armand, V-2, V-3, V-4

GIRAUDON, IV-2, X-9, p. 153, p. 175

HALARY, Gérard, V-1

JOURDAIN, P.H. (Artephot), IV-1

MARKS, Jeremy (Woodmansterne, Ltd.), II-2, X-8, p. 173, by permission of the Governors of
DULWICH COLLEGE

NEGRO, Vincenzo, X-7, p. 177, p. 181

REALE FOTOGRAFIA GIACOMELLI, X-11, p. 155

SCALA, X-15, p. 163, p. 167

PHOTOGRAPHIC SERVICE OF THE BIBLIOTHEQUE NATIONALE, PARIS, VI-1, VI-2, VI-3, VI-4, VI-5,
VIII-1, VIII-2, VIII-3

PHOTOGRAPHIC SERVICE OF THE PUSHKIN STATE MUSEUM OF THE ARTS, p. 151, p. 169

PHOTOGRAPHIC SERVICE OF THE MUSÉE DES BEAUX-ARTS DE TROYES, p. 147

THERIEZ, Cl., p. 165

VARGA (Artephot), VII-3

WOLF, A., VII-4